# ADVANCING AMERICAN ART

For Caroline –
Given in friendship – and
with affection
Taylor
Maltby

# ADVANCING AMERICAN ART

## PAINTING, POLITICS, AND CULTURAL CONFRONTATION AT MID-CENTURY

Taylor D. Littleton and Maltby Sykes

with an Introduction by Leon F. Litwack

THE UNIVERSITY OF ALABAMA PRESS
TUSCALOOSA AND LONDON

Library of Congress Cataloging-in-Publication Data

Littleton, Taylor.
Advancing American art: painting, politics, and cultural confrontation
at mid-century/Taylor Littleton and Maltby Sykes: introduction by Leon F. Litwack.
p. cm.
Includes index.
ISBN 0-8173-0426-6 (alk. paper)
1. Painting, American—Exhibitions—History.
2. Painting, Modern—20th century—United States—Exhibitions—History.
3. Avant-garde (Aesthetics)—United States—History—20th century.
4. Art and state—United States.   5. Art—Political aspects—United States. I. Sykes, Maltby.   II. Title.
ND212.L58   1989
759.13′074′014—dc19                                        88-27655
                                                              CIP

British Library Cataloguing-in-Publication Data available

For: Lucy, Marjorie, and Mary Wood

# CONTENTS

# PREFACE

The following pages tell the story of an art exhibit called "Advancing American Art" which, for a few months forty years ago, attracted an extraordinary amount of national attention as it temporarily became a center within the whirling vocabulary describing public attitudes toward modern art in the first postwar decade. During the last ten years or so, as our scholarly and cultural interest in the forties has increased, a few abbreviated versions of the story have appeared within larger contexts of discussion, addressing such themes as the Cold War political uses of modern art, the exploitation of American culture as an instrument of State Department diplomacy, and the evolution of governmental policy toward the arts.[1]

However, the story of "Advancing American Art" deserves an ampler narration. The premises on which the exhibit was formed for its projected diplomatic tour of Europe and South America and the prudent selection of the pictures themselves—despite the almost hysterical objections to them at the time—created a collection which seems to represent rather well the array of avant-garde painting being produced in America during the thirties and forties, prior to the advent of the radical Abstract Expressionist mode. The conditions of the curious public sale into which the exhibit was forced by its notoriety allowed a sizable portion of the collection to remain intact and to be transported to the South, bringing with it and sustaining for a new generation of viewers an increasingly valuable image of an important stage in the history of American art. All of the thirty-six paintings purchased by Auburn University in 1948 are reproduced in a final section of this book, with a commentary on each by Professor Maltby Sykes.

The account of this unexpected involvement of Alabama with the New York art scene is itself intriguing,

but even our newly acquired Sun Belt perspective must be startled by the mere facts of the fiscal transaction alone. For it seems incredible that in 1948, a public institution like Auburn University, struggling economically, could have acquired from the government for outlays of one hundred dollars—or even half that—paintings now valued at a quarter of a million dollars each, or could even have secured such lesser bargains as paintings purchased for sixty or one hundred dollars whose values have by now increased by 800, 900, and 1000 percent.

We are now able, of course, to see more clearly the relationship between art and politics during the decades just before and after World War II. We can understand, for example, how the organized Fascist repression of the arts and the violent condemnation of abstract and expressionist painting by the early Hitler regime affected, during the same period, the complex reaction of the American modern-art community to communism. For to many artists—including some of the "Advancing American Art" painters—communism then seemed a force which was politically opposed to such an event as the infamous "Degenerate Art" exhibit sharked up by the Nazis in 1937.[2] Expressions of leftist sympathies, either symbolic or overt, obviously had little real significance after the war, especially as official Soviet attitudes toward nonrepresentational and nonpatriotic painting were gradually revealed to be as abusive and malevolent as those prevalent in Nazi Germany. But by then, "communism" had become the new fright-word, and conservative attacks on "subversive" artists and the un-American nature of abstract art in general were a common feature of the emerging hysteria. The present volume attempts in part to define the location of "Advancing American Art" along this irregular continuum, which would end rather remarkably in the fifties with the dynamic transformation of modern art into a Cold War symbol of American freedom of expression.

But the chronicle of this almost forgotten exhibit is less art history than it is the account of an event which tells us something about America after the war, when the first half of the century was drawing to a close. Certainly the meanings and associations which in retrospect seem to cluster around that event are not in themselves fully adequate to explain the confused plurality of American life in the late forties as the nation

sought to reconcile its sacrificial experiences of the Depression and the war with its unsettling role in the new international theater. However, imprinted though some of them are with heated rhetoric and ambivalent motives, these meanings may nevertheless create for us a suggestive addition to our mid-century memory. For a reconsideration of "Advancing American Art" captures a significant transitional moment, defining briefly but clearly the figures of confrontation which affected the shape and folds, so to speak, of the cultural garments being worn in that critical period of postwar passage. Those figures of confrontation and challenge of American self-conceptions, as Professor Leon Litwack's essay makes clear, would become increasingly visible in the fabrics of the fifties. And, to be sure, they have reappeared in varied patterns of expression to mark the life of subsequent decades, including that in which we live today, over forty years later.

Auburn University, Alabama

# ACKNOWLEDGMENTS

The authors are grateful to a number of persons whose advice, encouragement, and assistance were invaluable in the preparation of this book: to the Trustees of the John and Mary Franklin Foundation for generous financial support of research activity; to Margaret Lynne Ausfeld, Acting Curator, Montgomery Museum of Fine Arts, for her work in organizing in 1984 the retrospective exhibition, "Advancing American Art 1946–1948," and for her concise, informative essay in the exhibit catalogue; to Harry Lowe, Deputy Director Emeritus of the Smithsonian's National Museum of American Art; to Linda Kaplan of Washington, D.C., for her professional appraisal of current market values of certain paintings reproduced in the text; to William Highfill, Auburn University Librarian, Harmon Straiton, Head of the Draughon Library Microforms and Documents Department, and David Rosenblatt, Assistant Director of the Auburn University Archives; to Mary Waters for editorial advice; to Mary Beth Bridges for research assistance; and to Sandra Ramey for preparation of the manuscript.

# ADVANCING AMERICAN ART

# INTRODUCTION

## THE NIFTY FIFTIES
### Myth and Reality
### Leon F. Litwack

The indispensable strength of this nation remains freedom of expression. If there is reason to be proud of our heritage, it is in the right we exercise to dissent, to say what we please, to write what we please, to sing what we please, to paint what we please. "Advancing American Art" stands very much in that tradition. Throughout our history, the role of the artist, like that of the musician, the philosopher, the novelist, the poet, and the scholar, has often rested on the willingness to be disturbers of the peace, to probe the nation's myths, to expose the contradictions between American ideals and American practices, to force Americans to reexamine assumptions and to see and feel in ways that may be genuinely disturbing. For this very reason, artistic expression has often led a precarious existence, as in the late 1940s and in the 1950s, when it provoked suspicion, hostility, and outright repression, when dissent itself—both artistic and political—seemed somehow illegitimate, unpatriotic, and un-American.

Few decades in our history are without those picturesque qualities that later generations recall with nostalgia. The memories tend to be highly selective, avoiding the disagreeable and the divisive. The 1950s came to be remembered with fondness some twenty years later by an emotionally exhausted America seeking to recover from the traumatizing experiences of political assassinations,

1

racial violence, campus disorders, the Vietnam War, and the Watergate revelations of crimes in high places. By the mid-1970s, any distractions, any reassurances were more than welcome, and the fifties provided a useful escape. To think of that decade was to invoke a plethora of cliched images: ponytails and Hula Hoops, saddle shoes and white bucks, duck tails and tail fins, hot rods and Edsels, Howdy Doody and Mickey Spillane, Davy Crockett and the Playboy Bunny, Milton Berle and Ethel Merman, Norman Vincent Peale, and *Readers's Digest*.

To Americans twenty years later, the fifties seemed comparatively calm, comfortable, and stable. Dwight David Eisenhower, who presided over most of the decade, personified those very qualities. Affectionately called "Ike," flashing his boyish grin, he was in every way comforting and reassuring. It was a unique period of peace and comparatively good times. Eisenhower terminated the war in Korea, he kept the nation at peace, he refused to commit American youths to combat situations (as in Indochina), and his "dynamic conservatism" left intact the bulk of the New Deal and Fair Deal social programs. Over the past quarter of a century, in scholarly works, as in the periodic polls of historians, the assessment of Eisenhower and his presidency has grown increasingly positive.

"The Nifty Fifties," was how *Life* magazine labeled the decade in 1972 in a special issue of nostalgic recollections, featuring a girl in a Hula Hoop on the cover. In a lengthy article, replete with photographs of the fifties revival underway, the editors eulogized the period: "It's been barely a dozen years since the 50s ended and yet here we are again, awash in the trappings of that sunnier time, paying new attention to the old artifacts and demigods." Even the more sophisticated journals found something reassuring to say about the fifties twenty years later. A writer in *Commentary*, in a piece entitled "In Defense of the Fifties," called the decade "the happiest, most stable, most rational period the Western world has known since 1914."

Whatever the psychological or ideological needs that produced such nostalgia, the perceptions on which it rested verged on sheer fantasy and make-believe. There was no hint of conflict, no awareness of the cultural tensions and hostilities which the "Advancing American Art" episode had revealed only a few years earlier. There

was no suggestion of the contradictions, the hysteria, the fears, the sheer madness that pervaded the decade: the Smith Act trials, the House Un-American Activities Committee, loyalty oaths, the execution of Julius and Ethel Rosenberg, the Emmett Till lynching, rampant careerism and a stifling conformity on college campuses, sexual liberation in the form of the Kinsey report, *Peyton Place*, and *Playboy* magazine. Nothing was said about the patriotic paranoia, the obsession with loyalty, the corruption of culture, the deep and persistent apprehension about the infiltration and betrayal of the nation's major institutions, or the equally pervasive concern about physical survival.

This was the decade in which Americans learned to live with the bomb, and some dug shelters in their backyards and prepared for the worst. In the Korean War, which lasted from 1950 to 1953, Americans once again sent their young men abroad to fight and to die, this time for a cause as difficult to understand as the terrain on which the war was fought and the people who were being fought against and defended. Not even a decade had passed since the United States had emerged triumphant from World War II. And even if Americans had

been more skeptical this time around about a war to end all wars, the spectacle of renewed conflict had to be disheartening and troubling. "We were traumatized not only by what we had been through and by the almost unimaginable presence of the bomb," William Styron wrote of postwar America, "but by the realization that the entire mess was not finished after all; there was now the Cold War to face, and its clammy presence oozed into our nights and days. When at last the Korean War arrived, some short five years later, the cosmos seemed so unhinged as to be nearly unsupportable."

With its abundance of natural resources, with its enormous power and monopoly of the atomic bomb, the United States in the aftermath of World War II stood in a position of unassailable superiority. President Harry Truman did not exaggerate when he told the American people, three weeks after the end of the war, that they possessed "the greatest strength and the greatest power which man has ever reached." For Americans, who have tended to think of the future as a constantly improving version of the present, it was a time of self-congratulation and great expectations. The future would be an American future. The twentieth century, said Henry

Luce of *Life* and *Time* magazines, would be the American Century. No less ebullient, liberal columnist Max Lerner proclaimed America "the only fabulous country," and historian Daniel Boorstin was moved to ask, "Why should *we* make a five-year plan for ourselves when God seems to have had a thousand-year plan ready-made for us?"

But within two years, the American people found themselves in a situation for which there were no apparent historical precedents: a Cold War, based on the perceived threat of a monstrous international Communist conspiracy. From its headquarters in Moscow, this conspiracy was said to be bent on world conquest and the subversion and destruction of the American Way of Life. The challenge Americans faced was both formidable and frustrating. In its attempts to reorder the world, the United States came to discover that the influence it could command, based on its superior economic and military power, was far less than it had assumed. The world refused to conform to American ideals and expectations. Nations might be inspired by the American example, they might aspire to the same material plenty, but they were determined to resolve their conflicts and problems within their own cultures, needs, and aspirations. Accustomed to the role of destiny's elect, however, and in possession of the most lethal of weapons, Americans found it difficult to accept limits to their power and influence.

For the impact it would have on American society, politics, culture, and the economy, the fear of the Soviet Union and Communist aggression and subversion ranks among the most extraordinary and far-reaching developments in American history. It distorted the economy, paralyzed politics, and debased culture—strongly influencing, for example, the recall in 1947 of the State Department art exhibit which is the subject of this book. It eroded the tradition of dissent and critical inquiry. The psychology of the Cold War became so deeply entrenched in Washington, D.C., in the nation's press, in academia, in the churches, in the trade union movement, and in the minds of most Americans that only one point of view survived. To debate the assumptions on which the Cold War was based, to question the constant and inevitable danger of Soviet military and ideological aggression, to challenge the validity of official perceptions of Soviet behavior was to seem indifferent to

national security. Debate was effectively stilled, anti-communism became the definitive test of patriotism and loyalty, and a generation of dissident Americans found themselves excluded from positions of public responsibility and influence.

During World War II, the image of the Soviet Union in the American mind had been transformed from that of an ideological enemy to a sincere and gallant ally. Hollywood in 1943 produced *Mission to Moscow*, a highly favorable view of the Soviet Union based on the book by Joseph Davis, the former ambassador to Moscow. The same kind of win-the-war patriotism induced *Life* magazine, also in 1943, to devote an entire issue to the USSR. Stalin appeared on the cover, and the magazine lavished its praise on the heroic Russian people and the Red Army. But within two years of the end of World War II, the American people were encouraged by various public figures, intellectuals, and the mass media, to transfer their hatred of Hitler's Germany to Stalin's Soviet Union. Based on their deeply rooted fears of socialism and communism and on previous suspicions of the USSR, the American people made the transition with remarkable ease and conviction.

The language employed to describe for Americans the nature of the Red Peril has been compared to the language which religions have evoked in the past for describing the eternal struggle between light and darkness. President Truman articulated the growing confrontation with the Soviet Union in a rhetoric which virtually precluded debate: "We must not be confused about the issue which confronts the world today. . . . It is tyranny or freedom. . . . And even worse, communism denies the very existence of God." The president, along with the media, divided the world, irreconcilably, into camps of good and evil, the godly and the godless, the chosen and the damned, and Soviet communism came to symbolize everything Americans had been taught to fear and despise—the very depository of evil. Once the foreign policy of the United States came to reflect such rhetoric and to rest on such sharp distinctions, any debate concerning its wisdom or rationality became impossible. Henry A. Wallace, former vice-president under Roosevelt, emerged for a brief time as the principal critic of American foreign policy. Although Wallace commanded little support and waged an ineffectual campaign, J. Edgar Hoover still thought it necessary to order his FBI agents

to follow him, to open his mail, and to tap his supporters' telephones.

The actions of the Soviet Union in Europe (especially the 1948 coup in Czechoslovakia) hardened American attitudes. The "loss" of China (as though it was ours to lose), the detonation of the atomic bomb in the USSR, and the Korean War similarly reinforced American concerns. The spectacular revelations about Soviet spy rings, the Rosenberg and Hiss cases, the confessionals before congressional committees confirmed for many Americans the already prevailing suspicion that a group of men and women in this country, many of them in high places, were conspiring to undermine and destroy the nation's institutions. None other than the president himself proclaimed in 1951 that "our homes, our nation, all the things we believe in" were in grave danger, and the Truman administration responded to charges of being "soft on communism" by inaugurating an ambitious federal security program to identify and purge the government of "potential subversives."

Hollywood, too, made the transition, from films depicting a gallant Soviet ally in World War II to films that acknowledged the new set of villains and fed on the growing fears of internal subversion. The point was made in motion pictures like *The Red Nightmare, The Red Menace, Invasion USA, I Was a Communist for the FBI, Red Planet Mars, Iron Curtain,* and *My Son John*—films in which innocent Americans found themselves duped by people who looked very much like themselves (and in some instances were neighbors and members of the family) but who in fact were operatives of the Communist conspiracy. Popular fiction was no less reflective of the prevailing mood. Some one million Americans purchased copies of Mickey Spillane's *One Lonely Night,* in which the tough-talking, patriotic hero, Mike Hammer, boasted of his anti-Communist exploits:

> "I killed more people tonight than I have fingers on my hands. I shot them in cold blood and enjoyed every minute of it. I pumped slugs in the nastiest bunch of bastards you ever saw. They should have died long ago. . . . They never thought there were people like me in this country. They figured us all to be soft as horse manure and just as stupid."

With equal alacrity, Captain America, the Marvel

comic hero, switched from battling Nazis to exposing Communists: "Beware, commies, spies, traitors, and foreign agents! Captain America, with all loyal, free men behind him, is looking for you, ready to fight until the last one of you is exposed for the yellow scum you are."

The threat of an alien presence within the United States was brought home in such a way that it became increasingly difficult to distinguish between fact and fantasy, between, for example, Hollywood's scenarios of Red subversion and the warning of President Truman's attorney-general, J. Howard McGrath, that Communist conspirators reached into the very fiber of American life: "There are today many Communists in America. They are everywhere—in factories, offices, butcher shops, on street corners, in private business—and each carries in himself the germs of death for society." To any American who managed to see Hollywood's *Invasion of the Body Snatchers* in 1956, such warnings took on vivid proportions, as the movie showed decent members of the community being converted into zombies.

In a two-page spread in April 1949, featuring fifty individual passport-size photographs, *Life* magazine personalized the Red peril and provided further evidence to underscore the attorney-general's concern. The photos were of individuals designated by *Life* as "Dupes and Fellow Travelers" of the Communist conspiracy. The accompanying article did not actually claim any of them were Communist party members, but "innocent or not," warned *Life*, "they accomplish quite as much for the Kremlin in their glamorous way as the card holder does in his drab toil." Among those pictured were some of America's leading artists, writers, actors, educators, and musicians, including Charlie Chaplin, Albert Einstein, Dorothy Parker, Norman Mailer, Leonard Bernstein, Aaron Copland, Langston Hughes, Lillian Hellman, Clifford Odets, Arthur Miller, and Mark Van Doren. The principal offense they shared was having lent their names to causes which were deemed unconventional or critical of American foreign policy and American institutions. In *Life*'s assessment, if these individuals were not simply dupes or fellow travelers, they were "Super-Dupes" of the international Communist conspiracy. Such lists prepared the way for the blacklists of screen writers, actors, academics, and artists, many of them forced out of their careers because they were unable to explain their political views and affiliations or refused to

subject themselves to the degrading process of seeking clearance.

Whatever the perceptions, fantasies, and phobias that shaped public attitudes, the evidence suggests no genuine threat existed in these years of a Communist revolution or a military coup within the United States. There was no secret Communist army, above or underground. Nor could anyone prove any overt acts by the Communist party to overthrow the government or any significant party influence on the government's policies—certainly nothing even approaching the influence some people imagined the party had exerted. On the contrary, the Communist party had been reduced to a small and insignificant minority, some 31,000 in 1950, including FBI undercover agents. Much of the party's influence had declined by the end of the 1930s, and many had left the party, including its most illustrious and best known figures. The decline in influence and membership stemmed not from increased anti-Communist vigilance but from disillusionment with the Stalin purges, the Hitler-Stalin pact, and the continuing flip-flops in the party line to conform to Soviet policies. The decline in party influence and membership, however, did not satisfy federal authorities; on the contrary, it increased the alarm of J. Edgar Hoover, the militant anti-Communist head of the FBI, who suggested that the fewer the number of Communists the greater the danger. In his view, and he successfully conveyed his concern to those in high places—the White House and Congress—the very fact that the Communists had committed no overt acts designed to overthrow the government was a troubling and confirming indication that such action would be taken. That kind of logic was unanswerable, and it effectively paralyzed the few skeptics or critics who still survived.

The crusade for internal security swept the country in the fifties after most of the American left had become either anti-Communist or non-Communist. The most spectacular revelations, then, were not of immediate threats to national security but of political sins committed in previous decades. Repentant ex-Communists who appeared before the various congressional committees, ranging from movie director Elia Kazan to historian Daniel Boorstin, talked of their own involvement in the Communist party and named others who had been involved with them, but almost always in the past—in the

1930s, when the party had been identified with anti-fascism, civil rights, and labor and unemployment struggles, or in the 1940s, after the Soviet Union had become an ally in the war against Nazi Germany. None of the information supplied by these witnesses in the 1950s was necessary to internal security or to the containment of communism. Through various sources, mostly police informers planted in the party, the FBI already knew the names of Communist party members.

When committees like the House Un-American Activities Committee demanded that witnesses name names, they were less interested in the names themselves than in testing the witness's conversion to anti-communism. The decision to resist or cooperate with the committee—that is, whether or not to become an informer—rested on the individual's willingness to risk loss of employment and position in the community. The only way for witnesses to save themselves, to salvage their careers and reputations was to become informers. The only way to clear one's name was to betray one's friends and associates. Complicity in subversion, in the Communist conspiracy was absolved by confession, by a public display of repentance, by becoming a member of the informer subculture. "The confession in itself is nothing," Leslie Fiedler would write, "but without the confession . . . we will not be able to move forward from a liberalism of innocence to a liberalism of responsibility."

Joseph McCarthy made his political debut as an anti-communist crusader only after Democrats and Republicans alike had demonstrated the political advantages. More effectively than most, certainly more spectacularly than any of his political colleagues, the Wisconsin senator exploited the issue of Communist subversion for political profit. He did not himself create the fear of communism, nor was he individually responsible for the national obsession with Communist subversion. He exploited anti-communism after it had already entered the blood stream of the political culture. He infused the crusade with his own personality. He was able to explain to many fearful Americans the frustration of American power, and he gave them a set of villains, some of them the high and mighty. He also took on less significant figures, who were far more vulnerable and defenseless against his innuendos. Seeking to unearth treason and subversion, he subpoenaed a State Department employee

who some twenty-one years earlier had written a book criticizing marriage and football, and an anthropologist whose research demonstrated that northern blacks had better IQ scores than Arkansas whites.

Whether confronting the powerful or the weak, McCarthy leveled charges of Communist subversion with no factual basis whatsoever, as in the speech in Wheeling, West Virginia in 1950 that initially brought him national recognition: "I have here in my hand a list of 205 that were known to the Secretary of State as being members of the Communist party and who, nevertheless, are still working and shaping policy in the State Department." There was no list. "This was just a political speech to a bunch of Republicans," he told a reporter afterwards. "Don't take it seriously." The Wisconsin senator, in fact, never succeeded in discovering a single subversive. His most distinctive achievement lay not in the plots or spies he uncovered but in the skill and artistry with which he turned anti-communism into a highly profitable profession. He intimidated scores of politicians, he manipulated the press, and he managed to frighten millions of Americans into silence or collaboration. Attacks by opponents only fed his paranoia, only

confirmed his suspicions, only reinforced his need to do battle with the Kremlin's American agents. If he could not find any subversives, he would obligingly invent them.

Unlike some anti-Communist crusaders, Joseph McCarthy came to believe his charges. He became obsessed with the notion of internal subversion based on a monstrous international Communist conspiracy, and, in the end, he went too far. He suggested that President Eisenhower was "soft" on communism. He overexposed himself on national television to millions of Americans in what came to be known as the Army-McCarthy hearings. He became an embarrassment even to the most hardened anti-Communist veterans, who proceeded to brand him a careless anti-Communist. When shooting rats, Vice President Nixon reasoned in 1954, it was best to use a rifle because a scattergun might injure non-rats. Finally, McCarthy's colleagues in the Senate censured him, but on the narrowest of grounds, not for his unproved charges and accusations but for his crude tactics and for violating the rules and decorum of the Senate club.

The legacy of Joseph McCarthy, aside from the vic-

tims of his political persecutions, was to become the root of a common noun defining "the political practice of publicizing accusations of disloyalty or subversion with insufficient regard to evidence." But the values McCarthy espoused and the assumptions on which he had based his crusade remained mostly unchallenged. McCarthy was censured and quashed, but not McCarthyism. "The enormities of the musician who abuses the piano," wrote columnist Murray Kempton, "have a way of obscuring the disharmonies of the score which was appointed as entirely appropriate for him to play. Over attendance upon the excessive can distract us from noticing how bad the normal is." The fall of McCarthy left intact the bipartisan consensus on anti-Communism and the Cold War that had produced him in the first place.

The public manifestations of loyalty in the 1950s—the flag salutes, the oaths, the blacklists, the committees, the federal, state, and local purges—did nothing to achieve their avowed goals. But the costs would be enormous—in broken lives, in wrecked careers, in the debasement of intellectual and cultural life, in the impoverishment of public life. Poet Allen Ginsberg, in his 1956 lament, "Howl," mourned the tragic human waste: "I saw the best minds of my generation destroyed by madness." Norman Mailer remembered the decade as a time of suffocating conformity, when the creative mind gave way to the authoritative mind, when it became almost impossible to sustain the courage to be an individual. "Came the Korean War, the shadow of the H-Bomb, and we were ready for the General. Uncle Harry gave way to Father, and security, regularity, order and the life of no imagination were the command of the day. . . . A stench of fear has come out of every pore of American life, and we suffer from a collective failure of nerve."

What Americans liked and disliked took on a disturbing uniformity in the 1950s, by no means limited to attitudes toward Communists, Russians, Negroes, labor unions, and sex. In its search for symbolic heroes, *Time* magazine hailed the product of consensus: The Man of Affirmation. Sociologist David Reisman talked about other-directed Americans, responding to the mass values held by their neighbors and peers, whose every action and thought was shaped by the need to conform to the crowd. The very vocabulary that became fashionable

in the fifties celebrated the quest for consensus: "group dynamics," "groupthink," "group integration," "social physics," "interpersonal relations." The ultimate need of the individual was said to be "belongingness," and among the most popular slogans of the decade was "togetherness." It was when a person acted like everyone else that he or she was judged to be someone who belonged, a true American. In one of the very few rebellions of the fifties, the life-sized audio-animatronic Abraham Lincoln being prepared for Disneyland smashed his chair and threw mechanical fits that threatened the safety of the men working on him. But like nearly everyone else in the fifties, he was subdued in time for the opening, when he would mouth carefully selected platitudes deemed acceptable to the decade.

Historians in the 1950s found in consensus a convenient way to explain the American past. The old history that concentrated on conflict and class gave way to a new history stressing the harmonies, the enduring nature of American democratic values, the past as an upward march toward the light. The old muckraking accounts of "robber barons" like Andrew Carnegie, John D. Rockefeller, J. P. Morgan, and Henry Ford were re-

vised to accord these industrial pioneers their rightful place in the pantheon of capitalist folk heroes. "The architects of our material wealth," historian Allan Nevins declared in 1953, "will yet stand forth in their true stature as builders of a strength which civilization found indispensable. . . . Here is a wide field for the re-writing of American history, and the re-education of the American people."

Some historians enlisted in the Cold War itself, articulating the need to combat by every means the Communist peril. Samuel Bemis of Yale University told the American Historical Association that when American foreign policy is under attack from abroad, the historian must neither comfort nor contribute to his nation's enemies and critics. Samuel Eliot Morison, in his presidential address in 1950 to the American Historical Association, made clear his distaste for previous historians, particularly those of the 1930s, who had left the younger generation "spiritually unprepared for the war they had to fight." And in 1949, the president of the American Historical Association declared, "Total war, whether it be hot or cold, enlists everyone and calls upon everyone to assume his part. The historian is no

freer from his obligation than the physicist." By the end of the decade, historian John Higham, in surveying the new history, found it "strikingly conservative." Historians, he suggested, were engaged in "a massive grading operation to smooth over America's social convulsions"; they were discovering "a placid, unexciting past," a continuity in the American past which underscored the stability of the nation's basic institutions and the toughness of its social fabric. "Classes have turned into myths, sections have lost their solidarity, ideologies have vaporized into climates of opinion. The phrase 'the American experience' has become an incantation."

With few Americans daring to question basic assumptions and beliefs, there pervaded a certain familiarity and sameness about everything—and everyone. Kurt Vonnegut graduated from high school in 1940; some thirty years later, in recalling the fifties, he thought he knew why it had seemed so familiar to him.

> When you get to be our age, you all of a sudden realize that you are being ruled by people you went to high school with. You all of a sudden catch on that life is nothing but high school. You make a fool of yourself in high school, then you go to college to learn how you should have acted in high school, then you get out into real life, and that turns out to be high school all over again—class officers, cheerleaders, and all. . . . High school is closer to the core of the American experience than anything else I can think of. We have all been there. While there, we saw nearly every form of justice and injustice, kindness and meanness, intelligence and stupidity, which we were likely to encounter in later life. Richard Nixon is a familiar type from high school. . . . So is J. Edgar Hoover. So is General Lewis Hershey. So is everybody.

On the college campuses, indifference and apathy, rather than political conservatism, were the dominant mood. Graduation speakers spoke to classes that were largely cautious, passive, materialistic, and fearful of controversy and ideological contamination. If they seemed unaware of poverty, race, militarism, sexism, and inequality, if they were smug and complacent, so was much of the country. If they gave their elders no clear sense of who they were, it was because they were much like their elders. If they made a fetish of noninvolvement and the avoidance of controversy, they were much like the faculty who taught them and the admin-

istrators who managed them. On all too many campuses, it was a case of the bland leading the bland. Students had few gods or heroes, not even Ike. McCarthyism taught them to be careful in choosing their friends, affiliations, and ideas. The mass of college students, a teacher observed in 1957, "lead lives of quiet enervation." Still another noted, with some relief, that students were "politically comatose but not yet committed."

Educational administrators took pride in their master plans for expansion and consolidation. Both teachers and administrators were reassured by the products of their efforts. The generation who had been children during the Great Depression and who came of age during World War II valued their security and the promise of the good life. The demands of business were readily apparent: they wanted easily adaptable, noncontroversial, essentially conventional people, ready and willing to subordinate their personal values to those of the institution. The college graduate expected to conform, to enter the corporate womb, and to reap the promised rewards—increased earning power and enhanced social prestige.

After surveying the Class of '49, *Fortune* magazine thought its most distinguishing characteristic was a passion for security and the expectation of finding it in the large corporation. "These men don't question the system," an economics professor told writer William Whyte. "Their aim is to make it work better—to get in there and lubricate the machinery." At the University of California at Berkeley, President Robert Gordon Sproul told the graduating class of 1951 that they should conduct themselves as "straight thinking, right acting men and women," that they should avoid both "misguided" conservatives and "insane" radicals. Every graduate knew what he meant, and that it was far better to be "misguided" than "insane." The student speaker reminded the class of the war in Korea, that some were bound to serve there, and that the enemy—being Asian—had no concept of the worth of human life. "In the Orient this concept has not yet come to acceptance, but the danger is lessened by the absence of the most lethal of the terrible armaments."

No one would have known from this graduation ceremony that the University of California had just emerged from a divisive, destructive, demoralizing controversy

over the imposition of a faculty loyalty oath. In the tributes to the university as the marketplace of ideas, no mention was made of the official ban on political speakers and on Communists as members of the faculty. As late as 1959, in fact, Clark Kerr, newly inaugurated as president of the University of California, could say with the utmost confidence of the graduating class: "The employers will love this generation, they are not going to press many grievances. . . . They are going to be easy to handle. There aren't going to be any riots."

Dissent in the fifties was artistic rather than political, and much of it existed in a kind of cultural underworld, made up of men and women who, in the words of John Clellon Holmes, felt their consciousness "to be at a different level of evolution." The Beatniks or Beats rejected bourgeois society and values; they found the major institutions, like the government itself, immune to change and insensitive to feeling; they were cultural outlaws, existing on the margins of American society, and demonstrating in various ways their contempt for what William Burroughs called a "snivelling, mealy-mouthed tyranny of bureaucrats, social workers, psychiatrists and union officials." Joseph Heller, in *Catch 22* (1961), sug-

gested that what America called sanity was actually madness. His character, Captain John Yossarian, wages a desperate battle to preserve his sanity in the dehumanizing, degrading military bureaucracy. Perhaps the profoundest social critic of the decade was a standup nightclub comic, Lenny Bruce. He found his society rational but no longer sane, and he insisted on exploring this madness to its very roots. A deeply probing radical critic, he was not an ideologue and he had no political solutions. In parodying the most cherished American myths and beliefs, he challenged the complacency and hypocrisy of his audiences. He talked to them about blacks, prisoners, the Church, marital relations, homosexuals, the media, sex, and censorship. "People should be taught what is, not what should be," he told them. "All my humor is based on destruction and despair. If the whole world were tranquil, without disease and violence, I'd be standing in the breadline—right back of J. Edgar Hoover."

If Bruce and the Beats anticipated the rebellious sixties, most Americans in the fifties found them incomprehensible and in poor taste or had never heard of them. The literary, stage, and film success of the period

was Herman Wouk's *The Caine Mutiny*, which celebrated the virtues of conformity and authority. "The idea is," one of the novel's characters declares, "once you get an incompetent ass as a skipper there's nothing to do but serve him as though he were the wisest and the best, cover up his mistakes, keep the ship going, and bear up." By 1956, television viewers might already have outnumbered readers, and the American public was spending more time watching their newly purchased television sets than working for pay. The shows suggested mostly contentment and complacency, devotion to family and country, with little hint of social or racial conflict.

It was said of young people in the fifties that they no longer had anything to rebel against. Asked in *The Wild One* what he was rebelling against, Marlon Brando answered, "Whadda ya got?" But even in this relatively placid decade there were stirrings and suggestions of trouble ahead, considerable restlessness and questioning by the young, and a discernible demystification of the adult world. No one talked yet of generation gaps, but growing numbers of young people found themselves attracted to new musical forms of expression. The songs their parents listened and danced to suggested a people at peace with themselves, comfortable in their material possessions, self-assured in their way of life. But for a new generation, Elvis Presley in "Rip It Up" (1956), Carl Perkins in "Blue Suede Shoes" (1956), and The Crystals in "He's a Rebel" (1962) articulated teenage anxieties and voiced a kind of rebelliousness that Marlon Brando and James Dean portrayed in films like *The Wild One* and *Rebel Without a Cause*. And the black corrupters of white youth, as disapproving elders perceived them, were already offering in the fifties alternatives in dance, in rhythm, and in words: "race music," with its own set of values and attitudes, its own distinctive expression of feeling and emotion. Once whites learned to appropriate the blues and "race music" for their own needs, teenage music would never be the same again. Nor would American music.

Between 1957 and 1961, *Nation* magazine devoted an annual issue to the state of youth on college campuses. The titles suggested each year how the contributors— faculty and students—perceived the prevailing mood. In 1957, it was "The Careful Young Men"; in 1958, "The Class of '58 Speaks Up"; in 1959, "Tension Beneath Apathy." On December 1, 1955, Rosa Parks, a forty-two-

year-old black woman, refused to give up her seat to a white man in a bus in Montgomery, Alabama. A black leader recalled that moment: "Somewhere in the universe a gear in the machinery had shifted." On the Berkeley campus of the University of California, a radical political party formed in 1957 and three years later the House Un-American Activities Committee tried to hold hearings in San Francisco's City Hall, only to run into a massive demonstration, made up mostly of students from nearby colleges. To one young observer, hosed down the steps by police seeking to clear the building of demonstrators, the event transformed her political consciousness: "I was a political virgin, but I was raped on the steps of City Hall." Even as John F. Kennedy talked of new frontiers for Americans to conquer, black demonstrators in Greensboro, North Carolina, staked out a new frontier in the techniques of civil disobedience and protest: the sit-in. The title of *Nation*'s special campus issue in 1961 had an ominous ring to it: "Rebels With a Hundred Causes," and the lead article was entitled, "The Indignant Generation."

In the year John F. Kennedy was elected president, few Americans thought to question the legitimacy of their institutions. Bipartisanship characterized American foreign policy, and the same assumptions of the fifties informed that policy. The mood at home was one of contentment, and Kennedy voiced optimism about the ability of Americans to meet new challenges, most of them abroad or in outer space. But the hope and promise with which the decade began and with which many young people responded to Kennedy's vision of a New Frontier would soon be shattered by assassination, racial strife, and deepening involvement in a country previously unknown to most Americans—Vietnam. The consensus, along with much of the nation, came apart.

Few people in our history have cared more deeply about their country than some of its severest critics. This is the context in which "Advancing American Art" needs to be viewed. It is an event of the postwar years, in which a group of artists challenged certain inherited American attitudes. But even as they shocked conventional respectabilities, they affirmed the value and the possible dignity of human life. The story of the exhibit is a celebration of American dissent through artistic expression. It is also a reminder of the underlying fragility of the freedoms Americans cherish and enjoy.

# 1

# A Strange, Eventful History
## The Short Career and Long Life of "Advancing American Art"

*If I should tell my history, it would seem*
*Like lies disdained in the reporting.*
—Marina to Pericles, Pericles, Prince of Tyre

Writing in the first issue of 1947 for *Art Digest*, editor Peyton Boswell observed that though the nation's politics in the previous year continued to be very much to the right, contemporary expression in art as seen in gallery exhibitions and competitions contained a strong left-of-center emphasis, with many of the principal awards being claimed by modernists who had participated in the federally sponsored art projects of the thirties. And he went on to comment approvingly on what he took to be a significant event in the postwar art world: the movement of the State Department "seriously into the business of forming art collections for good-will tours, replacing dollar diplomacy with cultural diplomacy." Boswell was referring in part to the department's arrangements for a traveling exhibition of paintings borrowed from industrial collectors, such as IBM, Pepsi-Cola, and Encyclopaedia Britannica, which would go first to Cairo under the sponsorship of King Farouk and thence to Rome and other European cities. But more specifically he was alluding to the purchase of seventy-nine oil paintings, chosen by the department's art specialist, J. LeRoy Davidson, for a two-part exhibition, one to travel in Europe, the other in Latin America, under the title "Advancing American Art."

19

Several contemporary artists whose work had been chosen for the historically comprehensive industrial collection were also represented in the newly formed State Department group, for example, Stuart Davis, Max Weber, John Marin, Marsden Hartley, Ben Shahn, Arthur Dove, and Philip Evergood. John D. Morse, editor of the prestigious *Magazine of Art*, gave the two exhibits a multipage pictorial layout in that journal's January 1947 issue, and observed enthusiastically, ". . . that the paintings in these exhibitions were bought by so many different agencies, for so many different purposes, yet hang so harmoniously together, [they are] . . . surely an answer to those uninformed and inexperienced critics of modern art who find in it only confusion and chaos."[1]

Even as these ardent endorsements were being written, the two exhibits had already departed: the one in early December for Egypt to begin a long and successful international tour; and the two sections of "Advancing American Art," for Prague, Czechoslovakia and Port-au-Prince, Haiti respectively. Before their departure, the recently purchased State Department oils had been shown for three weeks in October 1946 at the Metropolitan Museum of Art and the majority of them had also been displayed subsequently during November and December in Paris within the multination exhibition of fine arts celebrating the first general conference of UNESCO. Boswell noted that the experimental State Department show in its modernity and purchase by public funds had already, during its Metropolitan Museum sojourn, drawn sharp criticism from conservative elements in the art world and from the Hearst-owned newspaper, the *New York Journal American*. But neither he nor anyone else concerned with the exhibit's purpose and future could have foreseen that within six months "Advancing American Art" would become the subject of a strident anti-Communist attack in Congress, and that it would be featured disparagingly in some of the nation's most popular magazines as an example of the alleged absurdities of modern art. And it would have seemed even stranger to anticipate the exhibit's acquiring so swiftly such political notoriety that newly appointed Secretary of State George C. Marshall would feel compelled to issue its peremptory recall and to approve its disassembly and sale as government "surplus property."

As we look back now from a forty year perspective at

this series of events, Boswell's easy rhetorical fusion of artistic modernity and leftist identity may seem a natural sign of what we take to be the heightened political and social consciousness of the time. But he, Morse, and others who initially reviewed and praised the conception and content of the exhibit also identified, if unknowingly, some of the very qualities which would assign to it an existence beyond that of a curious cultural artifact of the forties. They commended, for example, the effort to export to other nations an image of American achievement in art as a parallel to its highly visible industrial efficiency. They acclaimed the democratic nature of the exhibit because of the ethnic cross section of its artists and, without any thought to the political risks involved, supported the decision of the State Department to purchase rather than lease the paintings. And, finally, they praised the frankly contemporary and experimental character which Davidson gave to the exhibit, placing in his choices, as the *New Yorker*'s art critic put it, "an emphasis . . . more on what is being done than, as is customary, on what has been done—and done, frequently, again and again." All of these strains were brought together in the most complete and euphoric of the contemporary reviews by Alfred M. Frankfurter, editor of *Art News*. Writing while the exhibit was still being shown at the Metropolitan Museum of Art, he projected, somewhat ironically as things came to pass, that "Advancing American Art" was setting forth on "a blind date with destiny." Its balanced array of our "progressive" artists, he wrote—that is, those of "genuine artistic adventurousness"—would dispel for the foreign audience any notion of the academic or imitative character of contemporary American art. "This time we are exporting neither domestic brandy in imitation cognac bottles nor vintage non-intoxicating grape juice, but real bourbon, aged in the wood—what may justly be described as the wine of the country."[2]

The official rationale for the initiation of this bold political and cultural venture was set forth prior to the exhibit's American departure; it was written by Davidson himself and published somewhat obscurely in the December 1946 issue of *The American Foreign Service Journal*. He placed "Advancing American Art" within the context of a broad program of art exhibits envisioned by the State Department's newly organized Office of International Information and Cultural Affairs. The program

had as its proper purpose the enhancement of American cultural prestige abroad and, according to the department's analysis of the foreign press and of field reports from multiple sources, there was every reason to believe that a major showing of American paintings with a strong contemporary flavor would be most welcome at the European and Latin American sites identified for the "Advancing American Art" tour. Davidson addressed in some detail the delicate issue of using public funds to purchase the paintings. Leasing rather than purchasing, he explained, would be more expensive within the complex logistics of the exhibition's schedule. He stressed the fact that when the multiyear tour was completed, the pictures would be assigned to permanent collections in the libraries and other institutions responsible for promoting the department's cultural activities. He emphasized the department's ultimate objective of moving all responsibility for this artistic exchange activity into the realm of private philanthropy, using as an example the American Industry Sponsors Art venture. And, as a proper supplement to the eminent practicality of the enterprise, he chose five pictures from the new exhibit to be reproduced in the article, stating in the brief descrip-

tive captions to four of them their characteristic American qualities.[3] All in all, the article was a model of careful justification and would have provided for the journal's confined readership of professional staff and career diplomats, especially those in foreign embassies and consulates, reasonable and appropriate answers to any possible criticism of the exhibit or its governmental sponsor.

Unfortunately, the reasonable and appropriate questions were not asked, at least at home, even though Davidson went to some length, in his written exposition of the nature of the exhibit, to make sure that its content would not be an issue. The title itself, "Advancing American Art," was intended to define "the scope and the limitations of the selection," presumably by excluding works that were conservative in conception and technique and by including those which exemplified in their experimental character and illustration of modern trends the "advancing" spirit of American art. From his perspective of 1946, Davidson, within his chosen context, identified three general groups: what he called the "older generation" of artists, such as Walt Kuhn, John Marin, and Max Weber, who had been born in the late decades

of the nineteenth century and whose significant work had been initiated before 1920; those artists, such as Ben Shahn, Stuart Davis, and Yasuo Kuniyoshi, whose work became prominent in the early twenties; and those, such as Adolph Gottlieb, Robert Gwathmey, and Jack Levine, who had achieved recognition during the last ten years. Davidson's chronological groupings give an impression of the show's attempt to suggest the development and stylistic range of modern art in America, a theme borne out by the more elaborate classification of the exhibit's content in the *Art News* review by Frankfurter. The illustrative aim of the State Department collection also found a certain credence in that several of its artists were represented in an important exhibit which had opened in the spring of 1946 at the Whitney Museum and which was specifically dedicated to the historical issue of the modernity developed in American art following the famous New York Armory Show of 1913. In his selection of which pictures were to go to Europe and which to the American republics, Davidson sustained for each part of the exhibit a range of styles and carefully divided the work of the several artists who were represented by more than one painting.[4]

It may not be altogether accurate to represent Davidson as being "turned loose" by Assistant Secretary Benton along West 57th Street, as Boswell described it in his *Art Digest* review, to assemble the exhibition with dispatch. But once the concept of "Advancing American Art" had been approved, there was doubtless some urgency in getting the pictures identified, requisitioned, and purchased through official procedures so that they could be properly organized, shown locally, and shipped to Paris in time for the UNESCO conference. A review of the list of purchase prices and requisition dates published later in the *Congressional Record*, together with a list of gallery sources of purchase, reveals just how adroitly the whole thing was managed. Over fifty of the seventy-nine pictures were requisitioned during the first week in May, with four, including Shahn's *Hunger* and Guglielmi's *Subway Exit*, as late as October 2, just before the show opened at the Metropolitan. A few of the pictures purchased had been painted as early as fifteen to twenty years earlier (O'Keeffe's *Cos Cob*, 1926, and Davis's *Still Life with Flowers*, 1930), although most of those which bore a legible date had been executed within the previous five years. It would perhaps be an ex-

aggeration to say that some of the paintings were done specifically for the "Advancing American Art" purchase, but several which were requisitioned during the first week in May are dated 1946 and thus would have been seen and chosen in their gallery settings only a few weeks after their completion: Prestopino's *Trolley Car*, Evergood's *Fascist Leader*, Gottlieb's *The Couple*, Crawford's *Wing Fabrication*, and Gwathmey's *Workers on the Land*. Shahn's *Renascence*, Levine's *White Horse*, Guglielmi's *Subway Exit*, and Gwathmey's *Worksong* are also dated 1946. There is evidence to indicate that Davidson was fully supported in his efforts by both the artists selected and the gallery owners, who apparently sold the pictures at reduced prices. Only thirteen of the seventy-nine oils cost $1000 or more and these were primarily by artists with more established reputations, such as Kuhn, Weber, O'Keeffe, Davis, and Marin, whose *Sea and Boat* brought the highest price at $2500. The Downtown Gallery alone was the source for over 30 percent of the purchases—twenty-three paintings.[5]

In the spring of 1946, the established gallery scene to which Davidson hurriedly took his modest sum of $49,000 to do business largely exhibited the work of older, established modern painters, such as Marin and O'Keeffe and the group of artists such as Shahn and Davis who had been bound together by their participation in the political leftist experiences of the thirties. Davidson and his advisers were willing to identify this source as defining the scope as well as the limits of the exhibit even though it did not in the main include the work of younger artists like Jackson Pollock, Willem de Kooning, and Robert Motherwell, who were then being recognized by certain critics as among the period's truly avant-garde painters and were already being described as Abstract Expressionists. Davidson did purchase a few pictures from the Samuel Kootz Gallery, with which the vanguard artists were consistently affiliated—including two works by Abstract Expressionist artists William Baziotes and Adolph Gottlieb—but he apparently did not wish to widen the exhibit's content to include a significant display of the admittedly powerful and original but extremely difficult elements of automatist and biomorphic abstraction that was now emerging in the work of Pollock and others.[6] Because of these omissions, per-

haps, a retrospective view makes "Advancing American Art" appear considerably less representative of its stated conception than it did in 1946. But given all the conditions under which he was working and the plurality of the American art scene in the forties, it must be concluded that from an aesthetic point of view and within his apparently chosen parameters, Davidson did rather well in his choices. He seemed to think so, as did the principal art critics of the day, and, as one recent assessment succinctly states, ". . . the major figures he missed are balanced by the trash he avoided."[7] And certainly the State Department's judgment was absolutely correct in anticipating the enthusiasm and praise the exhibit received in the early stages of its projected foreign tour. What was badly misjudged was the cultural and political terrain at home.

Within the insulated milieu of art critics, museum directors, and gallery owners, there was certainly nothing farfetched in the notion of modern art communicating a particularly revealing and effective view of American sensitivity and creative energy. As the matter was expressed by Archibald MacLeish, shortly after being succeeded by Benton as assistant secretary for the State Department's Division of Cultural Affairs, political dialogue in itself was inadequate to resolve international tensions in the postwar world. An additional dialogue was needed: one that would touch the spirit. And, writing in the same issue of *The Magazine of Art*, editor John D. Morse remarked that American art had indeed become in this century international in character and was capable of "carrying the idea of 'one world' to thousands of Europeans and South Americans."[8] For some Americans, the idea of one world provided a proper, though short-lived ideological vista for the postwar period. That concept, however, was dramatically modified by the concurrent appearance of the most enduring metaphor of the time, the famous iron curtain definition adopted by Winston Churchill in an address delivered in March 1946. The accuracy of that image, identifying not one world but two—one open, the other closed—seemed to be confirmed by the reality of unfolding political events, particularly in Europe. Suddenly America had an urgent obligation to define its values and traditions internation-

ally, especially for the people of those nations whose minds were intimidated by the totalitarian voice. Or at least so the official argument proceeded from the Department of State, as indeed had been the case prior to Pearl Harbor, when the Division of Cultural Relations had been formed.[9]

It was within this broad context of cultural diplomacy that "Advancing American Art" was formed and projected as one element in an international definition of American reassurance, stability, and enlightenment. Davidson certainly attempted to make clear the character, purpose, and artistic parameters of the exhibit. But its public life, like that of so many cultural and intellectual issues of the forties, began and ended as part of an equation in which the common denominator was politics. Even to Edwin Alden Jewell, art critic for the *New York Times*, later to become one of the exhibit's most consistent defenders, it seemed "somehow odd to find the State Department sponsoring and presenting a show such as that now on at the Metropolitan." And though in his review, written during the exhibit's first week, he fully accepted and praised its modernity, he unwittingly struck a prophetic note by remarking that some observers would probably soon be making jokes about "what would happen were the Department of State to be as 'radical' in the handling of world affairs as it appears to be in its choice of art."[10]

The jokes about the pictures and the political backgrounds of some of the artists had, in fact, already begun. Some of the most influential appeared originally in the pages of the *New York Journal–American* and subsequently were reprinted in other Hearst-owned papers. In the best tradition of sensational journalism, the series is a mixture of ridicule and extravagant and specious generalization within an assumed stance of populist outrage. The first article appeared in the same week that the show opened at the Metropolitan, and, though placed well back on page 6, carried an arresting headline which blatantly called the exhibit a "Red Art Show" and pressed the "ironical climax" of the State Department's "officially refusing to compromise with international Communism" and yet sending abroad the work of "left-wing painters," such as William Gropper, Ben Zion, Stuart Davis, Kuniyoshi, and others, who were said to be members of Communist-front organizations. This political issue, however, was inadequate for sus-

tained exploitation and within a few weeks, after the show had closed in New York and portions of it were being exhibited in Paris, the *New York Journal–American* turned to the more emotionally ample theme of the exhibit's modernity.

In three extended pictorial articles "Advancing American Art" and, indeed, the abstract and expressionist forms of modern art itself were placed in distorted form before thousands of readers. The encounter was helped along by editorial comments accusing the show of being the work "of a lunatic fringe," concentrating "with biased frenzy on what is incomprehensible, ugly, or absurd," and by charges from minor representational painters that "the State Department Collection is a bunch of junk" and is not typically American in its portrayal of scene and character. Specific pictures from the exhibit were described with such titles and captions as "Lunatic's Delight" (Ben Zion's *Perpetual Destroyer*); "a picture a somewhat backward four-year-old might turn out to illustrate a nightmare" (Shahn's *Renascence*); "If you contemplate adding to the suicide rate, we recommend this picture for the guest room" (Guglielmi's *Tenements*); or, more elaborately (for Zerbe's *Around the Lighthouse*):

"SHEER LOVELINESS . . . Is there anything more beautiful than a dead fish? Of course there is: Two dead fish, for example, or three or five. That's what makes this painting . . . so wonderful. You get five dead fish. And so did the State Department!"[11]

The note of an alleged Communist presence was probably in itself sufficient to shorten the exhibit's life once that note was absorbed into the full discordant symphony of congressional investigation into un-American activity in government. The inevitability of its fate, however, was shaped even more surely by the introduction of this quite different strain of alleged disloyalty: the assertion, accompanied by ridicule, that the pictures selected for "Advancing American Art" set forth a distorted and disfigured portrait of the American scene, particularly since the exhibit contained no examples of art which depicted the nation's values and traditions in recognizable forms. The perceived danger of Red-corruption-from-within, of course, no longer grasps the national imagination with the same intensity that it did in the decade following the war. Still, the question of what America stands for has never lost its pervasive rhetorical power in both our domestic and our international dis-

course. Certainly it was easy enough during the subsequent congressional debates in the spring of 1947 for some politicians to demonstrate that some of the artists had belonged to organizations which, during the thirties, were sympathetic to communism. What the exhibit ultimately could not bear was this additional charge of being self-contradictory: that it was inadequate at this crucial moment in history to show the rest of the world what America was like. In retrospect, such an accusation against the exhibit and the cultural diplomacy it represented could not, perhaps, have been reviewed by a less hospitable jury: a new Republican Congress latently suspicious of any New Deal leftovers, a pragmatic give-em-hell president from the "Show-Me" state, and a new secretary of state, whose experience as general of the army would presumably not have equipped him to deal with a scandal involving Communist art and the misuse of public funds in his own department.

Something there is, of course, in a democracy where a minority sooner or later must protest being left out, not being chosen, and thus being somehow stigmatized as being obsolete or "unequal." And when the government, it seemed, exclusively chose for a prestigious and unprecedented overseas exhibit artists primarily working in abstract and expressionist styles, inevitably the complaints began. There were some artists, critics, and politicians, of course, who might not have called the exhibit "junk," but who held a deep-seated opposition to nonobjective painting and found absurd the notion that such works could truly represent American art. "Why not show Europe—if you are going to show Europe anything—what representative American painting actually is, instead of just one side of it . . . ?" asked the *New York Journal–American*'s chosen authority, who derogated abstract painting as the mere "skeleton" of art, devoid of warmth and beauty and inappropriate even for gallery exhibitions.[12] But there were other, less polite voices which, when threatened with exclusion, knew how to adopt the pressure-group tactics familiar to the democratic setting. The Allied Artists Professional League (AAPL) was an association largely made up of conservative academic painters and illustrators who, in their regional groupings, were advised monthly about issues supposedly germane to their professional and economic

welfare by the league's vice-president, Albert T. Reid, who wrote a monthly column for *Art Digest*. It was this group which initially introduced the charge of elitist discrimination.[13]

In the chatty style characteristic of the league's internal dialogue, drawing occasionally on a blue-collar mode and descending at times to the invective of intimidation, Reid first, in a letter to Secretary Byrnes in early November of 1946, excoriated the State Department for permitting this "one-sided" and radical selection of works which, he stated, as if directly rejecting Morse's "wine of our country" praise, are "not indigenous to our soil." Dissatisfied with Byrnes's subsequent response that a modern art show had been specifically requested, Reid attacked the validity and even the existence of such requests (they "are like those flying saucers"); moved quickly on to the public funds issue by damning the purchase of pictures "misrepresentative" of our national art and darkly predicting ("There has been an election recently . . .") an accounting for taxpayers of such a "ludicrous" effort based on a "flimsy excuse of international comity—or something." He ridiculed, in Hearstian style, the pictures themselves (" . . . a nude who appears to have been inflated with helium"); and, finally, adopted the accusatory line connecting many of the "Advancing American Art" painters with Communist ideology. In the midst of all this, the league complimented itself on its "dignity and restraint," insisting that its only concern was the "lop-sided" content of the exhibit which had resulted from ignoring "traditional art"; and, in one of its mercifully few aesthetic judgments, stated that "even the most staid of traditional art is 'modern,' if the artist be living."[14]

"Advancing American Art" was a ready-made target against which the league, using the highly charged rhetoric of disloyalty, could aggressively release its hostility and apprehension at the rising eminence of nonrepresentational styles in painting. And though a motive of commercial envy is clearly evident in its attack, the league's ability to stimulate an effective letter-writing campaign—write "today not tomorrow . . . the thing is spreading like wildfire"—and Reid's paraded affinity with the principal congressional denouncers of modern art certainly influenced the quick demise of the show.

The Christmas rush may have deferred immediate attention to it after it departed the relatively safe confines of the Metropolitan in December, but in February, a few weeks after General Marshall succeeded Secretary Byrnes, the exhibit was exposed to a public beyond the readership of art journals and the big-city press. Early in the month, while the exhibit was en route to Prague, Fulton Lewis, Jr., in the now well-established polemical style, ridiculed it on his national radio show, and *Look* magazine, in its issue of February 18, devoted a full page to a selection of seven of the paintings under the provocatively political title, "Your Money Bought These Pictures."

The *Look* magazine display communicated the controversy to its widest national audience and was undoubtedly influential, along with the orchestrations of the AAPL, in producing the large number of complaining letters which many congressmen subsequently claimed to receive. The seven paintings reproduced in *Look* were not burdened with the sarcastic captions published earlier in the *New York Journal–American* and the short accompanying article was not overtly judgmental. The choices themselves, however, subtly sustained the charge

that the exhibit somehow failed to represent that America so firmly fixed in the minds of the magazine's readers. Four of the seven pictures emphasized social-realist themes, two of the others depicted the ostensibly peculiar subjects of a fat circus-girl and a worried clown holding a donkey, while Tschacbasov's *Mother and Child* revealed a strangely "foreign" treatment of a subject charged with both sentimental and religious feeling. The pictures in this show were indeed different, as the article stated, from those of a more popular "conservative type" previously exhibited abroad, and through the State Department's purchases Europe and Latin America would certainly be able to see what they had requested: "a new kind of American art."[15]

What was now clear was the astonishing fact that an art exhibit was national news. And what seemed equally clear was that the whole matter would not escape close congressional scrutiny, particularly under a Republican majority in a critical pre-election year. The first stage in that scrutiny began early in March at the hearings of the subcommittee of the House Committee on Appropria-

tions charged with reviewing the State Department's budget proposals for 1948.

The hearings, on what was called the department's "art program," were highly ironic. The chairman was Karl Stefan (Republican, Nebraska), who had some two weeks earlier already contributed to a strident *New York Journal–American* headline through his quoted reaction to the *Look* article: "It is no wonder that foreigners believe the people in America are crazy."[16] Prior to introducing the art program as a point of contention, Stefan had queried Assistant Secretary Benton at length on the usual administrative issues of salaries, travel, and personnel work habits, and on such special topics as the employment of alien language specialists and the method of selection for the books to be sent overseas to the department's cultural center libraries. But what most clearly defined the political background against which "Advancing American Art" had unfortunately been placed can be seen in Stefan's extended declaration before the subcommittee that the spread of communism in Europe could be stopped only by addressing the problem of hunger and that "words, music, art and what-not" were of little value. Dissemination of "American food produced on American farms" to millions of starving Europeans crying for bread was the only effective answer and, evoking an extravagant historical parallel between the State Department's culture and information program and the "cake ostensibly offered with scorn to French revolutionaries in 1789," he concluded that in the present war with totalitarian savagery he did "not want my country to repeat the mistake of Marie Antoinette and reply 'Let them eat words.' " Stefan would repeat portions of the "food speech" before the full House on May 13, and in the process would, ironically, give an unconscious but strangely revealing description of Shahn's *Hunger*, the most powerfully evocative image in the "Advancing American Art" exhibit of war's human devastations: "It is too late for words so far as men, women, and children are concerned, and there are millions of them over there with hands outstretched asking for something to eat."[17]

Beneath Stefan's florid rhetoric obviously lay a deep ambivalence and even hostility toward the proper function in foreign policy of the kinds of intellectual and artistic communication being advocated by the program of Benton's division in the State Department (which also

included the Voice of America broadcasting system). This ambivalence would continue to be expressed by many congressmen and senators in subsequent debates later in the spring and summer. There is, however, little if any trace in Stefan's stance of the isolationist strain that was itself much in evidence during the Congresses which considered the postwar policies of the Truman administrations. In fact, though Stefan's food-not-words-or-art position was doubtless a reflection of his conservative midwestern grain-state constituency, it nevertheless looked outward. However, neither he nor most of his Republican colleagues would be fully prepared for the enormous and unprecedented conception of American foreign commitments toward postwar recovery which General Marshall, who had already appeared before the subcommittee, within two months would describe in the plan which would eventually bear his name.

Benton, throughout the lengthy and challenging sessions, defended the program reasonably well; however, his adroit response to Stefan's economic criticisms of the division's proposed thirty-one-million-dollar budget is revealing. The use of literature and the arts to sell an image of America to combat the conditions that lead to war by creating, as he testified, "a world environment where our people are understood . . . instead of being . . . twisted into false patterns and stereotypes" was, to Benton, a "good investment." In politically underbred countries like Greece and Czechoslovakia, such an investment could "persuade people that they want your merchandise and should buy your merchandise." This practical subordination of the arts to political purposes was, as Benton concluded, an integral part of the entire State Department's program. And, on the following day of testimony, when "Advancing American Art" was the specific subject, Benton was even more candid and specific in his use of the vocabulary of advertising as he defended the original rationale for the exhibit:

The theory underlying the purchase of the art is that Americans are accused throughout the world of being a materialistic, money-mad race without interest in art and without appreciation of artists or music. The men in our cultural institutes throughout the world, in their desire to show that we have a side to our personality as a race other than materialism, and other than science

and technology, write the Department from the field wanting examples of American art.

Now, of course, many think the modern art, so-called, is a better illustration of our current artistic interests in this country than the more orthodox or traditional forms of art. Here you have the first reason underlying the theory behind this program.

Another reason is that in our institutes throughout Latin America we need things to bring people in, to attract them and induce them to come in to visit us, at our cultural centers. One very good way to bring people in is to have art exhibits or music that many will want to come to see and hear. When you get the people in there—if I may put this idea very crudely, in terms of a user of time on the radio, who will play music for 55 minutes in order to talk about his product for 5 minutes, hoping he can attract you with his music, so he can then talk to you about, say Lucky Strikes—when you get them in to your cultural centers, attracted through techniques of this kind, you hope to create an environment in which the visitors will want to read books about the United States, study English, listen to talks about the United States, and so forth.

These two reasons constitute the theory. I think the theory is sound.

Even as Benton spoke during this particular day of interrogation, the subject of his remarks had already moved on its western hemisphere itinerary to Port-au-Prince, and in Prague enthusiastic crowds were being attracted to the newly opened American show in large numbers. In fact, the exhibit was so successful that retaliatory plans were begun at once in the Russian camp to open their own art exhibition, an event which would take place in mid-April, only a few days after Secretary Marshall ordered all of the "Advancing American Art" paintings to be held at both exhibition sites until further notice. Thus, just as the exhibit was beginning to accomplish the very mission for which it was created and apparently in the very manner which Benton had described, its cancellation was already imminent.

As Benton's testimony made clear, he and his associates, and undoubtedly Secretary Marshall as well, had obviously decided even before the congressional hearings began that the exhibit had become too heavy a liability for the department to bear in its budgetary proposals. Benton was prepared for the worst and had attempted to defend the $49,000 expenditure by sending Stefan a letter from a leading art dealer pointing out that the pic-

tures had been purchased at reduced rates and were worth considerably more than the department's investment in them. But Stefan, although he alluded to this letter, paid little attention to the economic issue since his subcommittee's opposition to "Advancing American Art" had been carefully constructed by the anti-modernist arguments begun a few months earlier by the Allied Artists Professional League. He actually produced a copy of Albert Reid's letter to Secretary Byrnes and then read from a letter written by one of his own constituents who, after admitting that he was "generally rated to be . . . the leading artist of Nebraska," cited the familiar contention that the purchase of the pictures was organized by an elitist group of New York dealers and museum directors whose artistic tastes simply imitated postwar trends in European art. "What you mean by sane art," he wrote, "which is American in spirit and yet conforms to all the new standards applied to modern art, is, I believe, such paintings as those of mine recently on display" in various New York shows. Now "here," said Stefan, "is an artist with a reputation, an American artist . . . who lives out there on the prairies of Nebraska . . . who has seen these pictures, and who disapproves

of them, which is a refutation I think to the letter of the man who wrote to you from New York."

Benton may have been prepared for the content if not the specific form of this provincial stance. And he probably anticipated as well the committee's perhaps exaggerated agitation over the political uses which the pictures could serve once they became, as government property, readily available for reproduction. But as he tried once more to establish the monetary worth of the pictures—being careful to make a distinction betwen this issue and whether, as he said, "the department should have bought them to begin with" or, more importantly, whether these were the "right" pictures—his argument was cut short. Stefan reached back for a stack of photographs of the exhibit and proceeded to thrust several, one by one, before the witness, asking repeatedly, "Do you know what this is, Mr. Secretary?" Although Benton would state later that he regretted not responding more specifically to the questions (he was certainly qualified to comment on the abstract/representational issue), he apparently felt the best tactic at the time was to enter the mood of derision and ridicule which Stefan and the rest of the committee had adopted:

**Mr. Stefan:** What would you say that was?

**Mr. Benton:** You are closer to it than I am, Mr. Chairman.

**Mr. Stefan:** Now you are closer to it than I am.

**Mr. Benton:** I would hesitate to pass judgment on it. My guess—.

**Mr. Stefan:** Would you say that is a seascape or mountainside?

**Mr. Benton:** I would hesitate to pass opinion on it. I am afraid the artist wouldn't like it.

**Mr. Stefan:** What is that?

**Mr. Benton:** I think you might ask Mr. Horan. That looks like some of his western country. He might have some judgment on it.

**Mr. Stefan:** What kind of country?

**Mr. Benton:** It looks like good country to leave behind you, Mr. Chairman.

**Mr. Stefan:** That [exhibiting] looks like a canyon in the night. I do not know whether I am holding this up right or not.

**Mr. Benton:** You are showing me the same one.

**Mr. Stefan:** No.

**Mr. Benton:** It looks like the moon.

**Mr. Stefan:** That isn't the same picture.

**Mr. Benton:** It looks like the first one.

**Mr. Stefan:** Certainly. You can't tell the difference, can you?

**Mr. Benton:** No. It looks very similar . . .

**Mr. Stefan:** Do you know what this is, Mr. Secretary [exhibiting]?

**Mr. Benton:** I think that is much more recognizable.

**Mr. Stefan:** Yes. What would that be, would you think?

**Mr. Benton:** It seems to me to be a city scene that has very little resemblance—

**Mr. Stefan:** That is a bank-night scene, in front of a picture show. You know what a bank night at a picture show is?

**Mr. Benton:** Yes.

**Mr. Stefan:** That is a bank night.

**Mr. Benton:** It doesn't look like anybody that I know.

**Mr. Stefan:** Look at that, Mr. Secretary [exhibiting]. Those are supposed to be human beings, in a discussion, on a street in the United States somewhere.

**Mr. Benton:** Mr. Chairman, I have sponsored art collections myself.

**Mr. Stefan:** Aren't you horrified yourself?

**Mr. Benton:** I would not use the word "horrified."

**Mr. Stefan:** Well, you are shocked, aren't you?

**Mr. Benton:**   No; I wouldn't say I was shocked.

**Mr. Stefan:**   Well, what would you say?

**Mr. Benton:**   I would say "Art."

**Mr. Stefan:**   Depicting America as it is?

**Mr. Benton:**   That was not the purpose of the art, to depict America as it is; but your showing me these pictures—

**Mr. Stefan:**   How do you like this circus girl?

**Mr. Benton:**   I like her better than many others seem to like her.

**Mr. Stefan:**   How would an American circus girl feel about that?

As the laughter subsided, the questions turned more precisely to the budget requested for the division's projected schedule and securing of materials for overseas exhibits in 1948. "And pictures like these?" queried Stefan, holding up more of the photographs. "No more will be purchased like these," answered Benton.

**Mr. Stefan;**   They are out?

**Mr. Benton:**   They have been out for a long time, long before this story came out in *Look*.

This confirmation that the exhibit had for weeks been regarded in the Department of State as a political and administrative disaster brought the hearings to a close as one of Benton's assistants made sure that the congressmen present should understand that "portraits of George Washington, Abraham Lincoln, Thomas Jefferson, and other appropriate figures of American history" would be sent abroad as part of the cultural program. But if the fate of the exhibit had already been decided, the blame for it had also been fixed, as Benton defended the theory behind it but charged that the whole affair was not "properly handled." Davidson was not mentioned by name, but there was no mistaking Benton's implication to Stefan: "It is an extremely dangerous business for any individual within a Government department to take the responsibility for selecting 79 pictures. The greatest genius in the world could not select 79 pictures that would appeal to any of us as all being good pictures."[18]

Though Davidson had, in fact, secured advice from prominent figures in the New York gallery setting (as General Marshall made clear in an explanatory communication to Stefan), he had of course been consist-

ently identified in press accounts as the person responsible for selecting the pictures. By the end of April he had resigned and his position as visual arts specialist had been eliminated from the budget of the Office of International Information and Cultural Affairs. Even then, Davidson was harshly attacked in the subsequent congressional debate in May over the State Department budget and, years later, continued to be stigmatized in the official account of Benton's career as the person chiefly responsible for the exhibit's failure. Benton in his testimony was probably correct in implying that had a group of art experts been officially charged with making the selections their authority might have made a difference to the exhibit's public reception. But it is difficult in retrospect to see how the ultimate rejection could have been avoided if, in fact, the essential conception had been sustained. The selection of individual pictures may have been slightly altered but they would still have carried the liability of their modernity and of their strange and innovative forms. Moreover, their purchase with public funds would have made them still vulnerable to such sarcastic congressional remarks as, "I am just a dumb American who pays taxes for this kind of trash . . . if there is a single individual in this Congress who believes this kind of tripe is . . . bringing a better understanding of American life, then he should be sent to the same nut house from which the people who drew this stuff originally came."[19]

Predictably, by the middle of May the committee had voted to deny the requested 1948 appropriation for Benton's program. A portion of the budget request would eventually be restored through Benton's effective work with the Senate, and the 80th Congress after lengthy debate would pass the Smith-Mundt Act, thereby establishing a permanent legislative foundation for a US information and cultural exchange activity. Still, there can be little doubt that the sensational publicity attending "Advancing American Art" permitted some congressmen to use it to their advantage in attacking the current administration's conception of postwar foreign relations, and, in fact, the whole progression of liberal New Deal policy. Indeed, as the 1948 presidential campaign heated up, the exhibit would continue to be resurrected in a political capacity, as allegedly indicating

the fiscal laxity of the Truman administration and its tolerance toward Communists and fellow travelers.[20]

Benton himself would not resign from the State Department until the following September. His influence on the eventual passage of the Smith-Mundt legislation was significant and his political career survived the hostile political condition to which the "Advancing American Art" issue contributed. Nevertheless, Benton absorbed his share of public criticism, especially after the disclosure, in early June, that President Truman had written to him two months earlier criticizing the exhibit in particular and modern art in general. This authoritative judgment, emerging as it did just before the House vote on the Smith-Mundt bill, stimulated such journalistic disparagements of Benton as that which appeared in the *Chicago Daily Tribune* of June 4: " . . . Republican leaders picture Benton as a gullible, big advertising executive who was played for a sucker by the Communists and other left-wingers who have dominated the Department broadcasts to Russia and other activities."[21]

Years later, long after he had entered other phases of public life, Benton would state that his principal reason for halting the "Advancing American Art" tour was his discovery that many of the painters in the exhibit were, justly or unjustly, on the attorney general's list of Communists and that allowing the exhibit to continue under State Department sponsorship would have allowed the Russians to exploit the matter, a move which in turn would have severely affected congressional attitudes.[22] Those attitudes, however, were affected anyway and, as indicated above, references to the connection of some of the artists in their earlier careers with Communist organizations had been pervasive in press accounts of the exhibit even before it left New York. Such information would have been readily available to anyone in Benton's division months before it was read into the *Congressional Record* in May. The decisions to recall the exhibit and eventually to disperse it through public sale were, to be sure, politically inspired. In retrospect, however, the significance of "Advancing American Art" seems to extend beyond that political dimension which often appears to enclose the life of so many public events of the forties. In a peculiarly innocent way, it helped to expose the difficulty postwar America was encountering in its attempt to reconcile the memory of an immediate past with the anticipation of an emerging, uncertain future.

In the closing paragraphs of Robert Penn Warren's *All the King's Men*, one of the principal American novels of the late forties, the symbolically named narrator, Jack Burden, reflects on his growing awareness of the crucial configuration of past and future:

> I tried to tell her how if you could not accept the past and its burden there was no future, for without one there cannot be the other, and how if you could accept the past you might hope for the future, for only out of the past can you make the future.
> I tried to tell her that.[23]

Like his companion Anne Stanton, Jack has witnessed and been marked by the promise and taint of the flawed career of the southern politician Willie Stark. With her, Jack must now reconcile that history, their history, if they are indeed to enter another to be created, as Warren says, in "the convulsion of the world." *All the King's Men* still derives part of its power through its redefinition of this tragic theme in human affairs: the urgency to find in the past a coherent meaning and intrinsic promise. But for us, and particularly for the wider subject of this book, the novel's further relevance lies in its social intersection of time and place. Published in 1946, the same year in which "Advancing American Art" was conceived and first exhibited, the novel released the contradictory and strangely prophetic figure of Willie, whose political fundamentalism and strident, corrupted sense of power made him a transitional and powerfully charismatic presence in an America still carrying Depression and isolationist memories but slowly seeking new forms of liberation for the enormous energy it had assimilated during the war.

Willie Stark has always, of course, waited in the wings of the democratic stage to emerge during pauses of hesitation or stress in the national life; and he was certainly present, however briefly, during the debates of the 80th Congress into which allusions to "Advancing American Art" were projected. Charges of connections between Communist themes, the artists, and the form and content of their pictures were set forth in the most demagogic and zealous patriotic invective, as published in the *Congressional Record*:

> Without exception, the paintings in the State Department group that portray a person, make him or her unnatural. The skin is not reproduced as it would be

naturally, but as a sullen, ashen gray. Features of the face are always depressed and melancholy.

That is what the communists and other extremists want to portray. They want to tell the foreigners that the American people are despondent, broken down or of hideous shape—thoroughly dissatisfied with their lot and eager for a change of government.

The Communists and their New Deal fellow travelers have selected art as one of their avenues of propaganda.

The tendency of the extreme political right during this period to vilify avant-garde art as Communist and the repeated quotation in public of passages such as this assigned a specific political connotation to the exhibit. Its danger to the nation's foreign relations had been created by an administration "infected by Communists" and by people in the State Department "who not only are not truly representative of America, but actually do not understand America and cannot speak our language." And even this kind of partisan denunciation could be echoed by supporters of Benton who were nevertheless convinced that the malignant influence of the New Deal still lingered in a vaguely subversive form:

The photographs [of some of the pictures from the exhibit] which the gentleman from Ohio has distributed here on the floor are in the main a picture of the old OWI which I think was completely controlled by those who exercised an influence detrimental to our country as a whole. . . . the program will not get a dime until they have washed out this whole set-up and regained the confidence of the Congress . . . that only those who are pro-Americans will be used to administer the program.[24]

However, when the rhythm of congressional debate on the whole issue of foreign informational relationships is examined closely, it is apparent that such strictly political interpretations of the exhibit were less prevalent than aesthetic ones. Allusions to the pictures themselves were indeed minor elements in the wider concerns of that body, which was the first Congress since the war to attempt a reconciliation between the new international claims on American power and a domestic ambivalence about the nation's own loyalties and identity. The full exploitation of this tension would not reach its height until after the decade had closed; but that agony (and its

demise) were already foreshadowed during the very month in which "Advancing American Art" was a brief congressional topic as Senator Tydings, in an exchange on the Senate floor with Senator McCarthy, anticipated that attempts to deny certain employment rights to a person because he allegedly supports Communist doctrine "might turn into a witch hunt."[25] And within the configuration of actors who would play out and ultimately conclude that complex drama, no role is more arresting for our story than that of Benton himself, who, as the newly elected senator from Connecticut, would offer, perhaps, the most striking and courageous gesture of his public career when he rose on August 6, 1951, and set before his reluctant colleagues the resolution to censure the junior senator from Wisconsin.

But now, on May 14, as the House moved toward completion of its debate on the Smith-Mundt legislation, an array of sensible speeches by Mundt himself, and by Representative Short, Trimble, Javits, and Gary argued strongly against the recommendations of the Appropriations Committee that funding for Benton's program be deleted. Both the House and the Senate were about to approve, after searching and emotional discussion, an appropriation of $400 million for Greek-Turkish aid, a clear commitment toward a new dimension of America's international involvement; and perhaps some members already knew of the administration's plan for massive aid for European reconstruction, which would be outlined by Secretary Marshall early in the following month. How, argued Javits, can one comprehend "the limited view . . . which would vote hundreds of millions for relief and foreign assistance and stop at voting a few millions for the right kind of a program to tell what we are doing and why?" Only an hour before, the "Advancing American Art" pictures had been characterized as a Communist plot, with Representative Rankin (Democrat, Mississippi) asserting that "no American drew these crazy pictures"; and Representative Jennings (Republican, Tennessee) castigating the State Department for not sending to people in foreign countries an image of "what American women look like" but rather sending "a caricature, a squat creature of the muck and mire," holding "this misshapen thing up to the world as an American circus performer taking a rest." Copies of

the pictures were also passed around to the apparent great amusement of many of the House membership, with comments such as those by Representative Brown (Republican, Ohio) that one "represents sleepy-eyed potatoes in the springtime" and that perhaps "the gentleman from Massachusetts [Representative McCormack]" could explain the meaning of another "that has a colonial hat placed jauntily upon a skeleton."

Clearly the art business had been a ghastly mistake but, with efficient and watchful administration under the proposed legislation, such an error was not likely to occur again. And besides, the argument ran, the art fiasco should not obscure the larger issue of our responsibility, unprecedented in peacetime, to hold up to the world "an honest mirror of what America is and how Americans live." What we need from the department is an information program that "would penetrate the iron curtain" by "telling our economic, political and social story." The discussion, therefore, moved on to the nature of the verbal and printed media to be exported, especially through the Voice of America broadcasts, which had always been at the center of Benton's program. Appropriations Committee chairman Taber and subcommittee chairman Stefan were gently chastised for their lack of perspective in "chasing the Circus Lady." Finally, late in the day, Representative Eberharter (Democrat, Pennsylvania) rose to join with others in asserting that the urgency of the State Department's information program not be misconceived. But then he said something more, something that perhaps needed saying by a member of that body. He had observed, he continued, that for fifteen or twenty years in the international art exhibits held at the prestigious Carnegie Institute in his home district of Pittsburgh, the prizes had usually gone to "what is called abstract painting" and that probably the pictures in this exhibit, photographs of which had been handed around and laughed at that very morning, had an intrinsic artistic value and authenticity of their own. But given their modern character, regardless of who chose them for the exhibit, their fate within the democratic context of debate and public judgment was predictable:

I know that every time in the last 5 years that first prize was awarded in an art exhibition at Carnegie Institute . . . practically every newspaper ridiculed the selection

. . . and asked, in effect, "Who knows what this means?" "Is it art, and if it is art, I assume we do not know anything about art." Even columnists who are nationally known, take it as their theme that we had better give up on the subject of art; that the general public does not know what art is.

And, as if determined to illustrate personally his colleague's thesis, Representative Chelf (Democrat, Kentucky) vehemently delivered the final observation that if Congress and the American people cannot understand these pictures they should not have been sent overseas. Moreover, if any pictures are to be sent abroad, "we should see to it that they represent the American home or family life. Not some silly thing that resembles the north end of a south-bound freight train which is inadvertently headed west."[26]

Thus it was that the image of "Advancing American Art," its substance now tentatively deposited in warehouses on two continents, departed from the halls of the 80th Congress, carrying with it something of the same ironic ambivalence with which it arrived: successful and yet a failure, democratic and patriotic, "the wine of the country" and yet "subversive." It is still not clear why this kind of ambivalence had not been predicted, why those who participated in the formation and launching of the exhibit had not understood the relationship between press, public, and modern art which Representative Eberharter had so matter-of-factly explained to his colleagues in the House. And despite the difficulties posed by the Byzantine corridors of communication within the State Department, Benton with all of his public-relations awareness would have to be included in the group who simply misread the temper of the time. They underestimated the power of "vicious old boys," like the AAPL's Reid and a few congressmen of the extreme right, to form a highly publicized context of derision and distortion. They also did not perceive that in 1946–1947 many Americans, though they could readily approve magnanimous economic and military gestures toward a devastated Europe, did not want a demonstration that their national art had become international, that it was advancing and had, in fact, advanced into a bond of solidarity with the modern art of the older culture. The exhibit was designed essentially for European viewing, but because of its sudden prominence, parts of

it were also viewed by millions of Americans beyond that segment of the public that would normally find its way to a new show at the Metropolitan. The taste of these citizens had in great measure been shaped by federal art programs of the thirties, programs which created an art of the post-office mural variety—deliberate glorifications of the American scene wherein cheerful heroic workers riveted girders and felled trees against a background of industrial might and rural vigor. And when rather mild versions of the forms and styles of modern art such as those contained in the State Department exhibit suddenly leaped into the media, presented in the most garish form, they immediately became easy targets. For a public nurtured on this kind of government-sponsored art, described by a recent critic as the most "philistine, propagandistic, banal form that has ever been produced in the history of art in this country," the response was not only that taxpayers' money shouldn't be spent on such pictures, but that "we shouldn't be spending our money on them because they don't look like what we have in the local post office." The pictures were not necessarily threatening: they simply seemed ugly, even comic.[27]

Forty years later, of course, the whole affair seems both more understandable and more complex than it did then; and certainly ironic too, for within a decade or so the US Information Agency would be sending examples of abstract expressionist art to Europe as an indication of the freedom of the arts in America. And "Advancing American Art" artists such as Stuart Davis and Max Weber, after being cited in the congressional furore as subversive and derogated along with other modernists by President Truman, would be welcomed to the White House at the inauguration of a new Democratic president.[28]

Caught, then, in an instant of time when all occasions seemed to inform against it, the exhibition by its very failure illuminates for us a condition of the period which would become increasingly unattractive as the decade waned. Nonobjective painting's peculiar and irrational vulnerability to charges of being un-American lasted well into the "nifty Fifties," particularly under the strident invective of Congressman George Dondero (Republican, Michigan), whose obsession with a modern art-communism connection is only mildly indicated by his statements that such art

. . . is communistic because it is distorted and ugly, because it does not glorify our beautiful country, our cheerful and smiling people, and our great material progress. Art which does not portray our beautiful country in plain, simple terms that everyone can understand breeds dissatisfaction. It is therefore opposed to our government, and those who create and promote it are our enemies.

The absurdly ironic resemblance, however, between Dondero's stance and the emerging clarification of official Soviet attitudes toward the arts did not go undetected. *Time* magazine in an issue published only a few months after the recall of "Advancing American Art" quoted the previous week's *Pravda* on how the revolution and government vigilance had saved Soviet art from the insidious influence of Picasso, Matisse, and the perverted decadent art of their modernist heirs in the West: "Soviet realistic representational art is the most advanced art in the world." And Peyton Boswell in the summer 1948 number of *Art News* commented specifically on the assertions of Dondero: "Only a great, generous, muddling democracy like ours could afford the simultaneous paradox of a Congressman who tries to at-

tack Communism by demanding the very rules which Communists enforce when they are in power" and of a few artists who at one time have idealistically been drawn to "movements sympathetic to Soviet Russia while they go on painting pictures that would land them in jail under a Communist government."[29]

All of this, of course, would pass, but the strain of philistinism and hostility to visual or intellectual challenges of a traditional self-image, which the "Advancing American Art" episode exposed (but did not create), would soon find other forms of fundamentalist expression in the national life. In the first year of the "nifty Fifties," for example, McCarthy would launch his career in the infamous Wheeling, West Virginia speech when he posed "the fate of the world" as resting between the clash of "the atheism of Moscow and the Christian spirit."[30] And within another five years, the phrase "under God" would be inserted into the Pledge of Allegiance (1954) and "In God We Trust" would be approved as the national motto (1956).

But "Advancing American Art" has an aesthetic reality which, it would appear, is more important than the exhibit's presence in a cluster of events which meta-

phorically define the domestic political environment of the immediate postwar period. The process by which American painting liberated itself from its provincialism is a long and complex story, its creative "triumph" occurring in the mid-to-late fifties, when the work of the New York School artists not only gained public acceptance but also began to be influential abroad.[31] The liberation itself, however, had perhaps occurred before the outbreak of World War II, by 1940, as recalled by Clement Greenberg, the principal observer and interpreter during the prewar and postwar periods of the development and emergence of the Abstract Expressionists within their New York milieu. Reviewing a retrospective exhibit in 1956, which included work from the thirties of painters like de Kooning, Hofmann, Gorky, Graham, and Pollock, Greenberg described these and others as by then "already [possessing] the fullest painting culture of their time." These artists, he wrote, had established their "full independence not by having turned away from Paris, but by assimilating her," achieving in the process a truly cosmopolitan but no less American art.[32]

But in 1940, these radical artists were relatively obscure and their work had not really been seen by the public. Though their period of learning and assimilation was behind them, they were still the outsiders, an avant-garde, secure only in their private reputations. And even after their first one-man shows began to occur at one or two New York galleries during World War II, none of them could have anticipated the critical adulation and subsequent financial rewards from gallery sales which would come their way within another decade. What happened to middle-class America's artistic tastes during that ten years or so is indeed a complex story and one still not fully understood. But prior to the war and during the rest of the forties, those tastes had seemed sufficiently fixed in their affinity for representational styles and American scene content so as to define the necessary conditions of rejection which motivated the innovations of the future Expressionists. And it is somewhere along this sequence between rejection and acceptance that our exhibit finds its place in the story, carrying a title which now seems more relevant than it possibly could have seemed then.

In its artistic content, "Advancing American Art" was certainly less significant than any number of other shows mounted during the late forties in the metropoli-

tan gallery environment and reviewed in the usual specialized art columns and journals. Some of its pictures with their social-realist themes seem to recall prewar absorptions; and only a few contain the kind of mythic and primordial forms, and none the hints of psychic improvisation, which were becoming distinctive elements in the paintings of the gradually emerging Abstract Expressionists. The substance of the exhibit would seem to be somewhere between these two limits, especially in the array of works, minor ones though many of them are, of several artists like Arthur Dove, Max Weber, Stuart Davis, John Marin, Marsden Hartley, and Georgia O'Keeffe, who were truly among the pioneers of modern art in America. Their styles had long rejected the static pictorial vocabulary of the regional illustrators and painters of the American scene. In the process, for some thirty years prior to World War II, their work had offered to a resisting native audience a different kind of artistic reality and the possibility of expanded aesthetic perception.

But in one obvious way "Advancing American Art" was unique in its sudden and meteoric encounter with the popular taste of a national audience. And, though it attained its prominence for the wrong reasons artistically, the extraordinary rage which it engendered we may now see as preliminary and perhaps even necessary to the gradual public toleration, recognition, and approval of abstract art which was already underway. That acceptance, enhanced within the new social arrangements fostered by postwar prosperity, including a population wanting to know more about art, may well have hastened the creative decline of the triumphant Abstract Expressionist achievement as those conditions described by Greenberg—rejection, separateness, and obscurity—began to disappear. In fact, Irving Sandler, in his comments on the "success and dissolution" of the Abstract Expressionist scene, notes that by the early fifties, many of the original group for whom sales to a philistine public "had for so long seemed an incredible fantasy" began to wonder whether their paintings now being bought by the "enemy" still possessed the anti-middle-class values so critical to their art. The important and continuing role of major museums in influencing popular tastes in art through catalog sales also seemed to find an early impetus after the war. For example, a Christmas review of seasonal cards and calen-

dars in 1946, especially the offerings of the Metropolitan Museum, the Museum of Modern Art, the Boston Museum, and the Art Institute of Chicago, stated: "With museums and artists' groups playing an increasing role in the field and commercial manufacturers and the Greeting Card Industry making concerted efforts to woo new painters . . . the greeting card is fast becoming a form of 'poor man's art,' as were the engravings of the Renaissance." And the director of the Art Institute of Chicago, discussing the widespread movement since the war among American artists toward nonobjective modes of expression, observed that the mass public, while not perhaps consciously aware of these trends in painting, actually was "even now being favorably conditioned for advanced art" through the appearance of abstract and surrealist principles in architecture, furniture, and printing design, and in many forms of advertising.[33]

The modern impulse to reexamine the function and meaning of tradition has, of course, a long, discursive, and imprecise history. And though subsets of that impulse in various artistic and literary forms themselves have complex international origins, the urge to see and define the world in different ways seemed to find consistent expression in America within the energetic, though confused, period of adjustment and reorientation after the war. One may therefore see "Advancing American Art," finally, as something of a minor harbinger, as an image of transition toward a developing plurality in the national life, a plurality which to some extent we have already seen illustrated politically in the stresses within the 80th Congress as it strove to deal with America's new international obligations and destiny. Perhaps that gradual tolerance of various challenges to the prewar aesthetic and intellectual legacy bore an association with the new scientific paradigm which began to assume its threatening, ambiguous and yet obsessive shape after the horrendous explosions of 1945. The new way of looking at the world demanded by the powerful and irresistible substructures of atomic science may well have been prefigured in the geometric and elastic abstractions of modern art—in the work of some of the "Advancing American Art" painters and of their greater predecessors and contemporaries. That affiliation is less important, however, than the intellectual climate which this startling vision of reality helped to foster: a climate in which

sounds, forms, and meanings heard or perceived before only within the limited pale of an avant-garde now emerged for a broader audience.[34]

Actually science itself, like the new art, seemed to pass through a transitional moment of introspection about its sudden prominence and its ambivalent public reputation: ". . . the people think of science more and more as a sort of black magic, threatening their traditions continually and likely to blow them up momentarily," as one contributor to *Science* explained. And in the same journal of 1947 this feeling of uncertainty could find a minor and even amusing expression in a note on the role of a new faculty committee at Harvard: to assure that the university's "most complex calculating machine," though still under Navy contract, nevertheless would perform "peacetime computations during a part of every day."[35] But this self-consciousness, of course, would also quickly pass as science was rapidly assimilated, both symbolically and bureaucratically, within the national esteem. During the same week in which the House was entertaining itself with the "Advancing American Art" affair, the Senate was debating the bill which in 1948 would create a National Science Foundation; and cer-

tainly there was a feeling by the end of the decade not only that the culture of science was now centered in America rather than Europe but that American science was truly international. Moreover, the president of the prestigious American Association for the Advancement of Science could say that its spirit of tolerance and open-mindedness, combined with its hostility to racial, national, or religious prejudice was somehow indispensable to the quality of the nation's life: "It makes no difference whether a discovery is made by a German, a Chinese, or an American, a Negro, a Jew, a Communist, or a Republican. The only criterion is whether the discovery is sound or not. Frontiers to science are unimportant."[36]

In the immediate years to come, this broad ecumenical expression would be challenged by the loyalty issue, which adversely affected the scientific establishment far more than the domain of arts and letters. Still, science as an image of vigor, purpose, and discovery seemed, for the first time in the late forties, to have become a shaping and deeply felt presence. The parallels between science and art as images of modernity, a liberation from the world of familiar form and from inherited patterns of expression and understanding, must remain both com-

plex and tenuous, but each did in its own way challenge or demonstrably alter traditional ways of perceiving experience and the world around us. It was this general tendency of the modern sensibility that LeRoy Davidson apparently tried to explain to the benighted mind of Congressman Busbey: that an abstract painting, like some of those in the "Advancing American Art" exhibit, because it presented a vision or impression of experience complete and autonomous in itself became more real than conventional imitations of observed reality. The attempt, of course, was fruitless: "From my discussions with Mr. Davidson, I came to these conclusions: the pictures of . . . recognized . . . old masters are too drab, uninteresting, and too natural. . . . The movement of modern art is a revolution against the conventional and natural things of life as expressed in art . . ." While part of the thesis was captured, if slightly overstated, the rest, that in nonobjective art the inheritance of the past was creatively assimilated and recast in new and original forms, could be seen by Busbey only as a derogation of tradition, as "ridicule" of those "institutions that have been venerated through the ages. . . ."[37]

The fate of "Advancing American Art" was fixed, of course, long before this conversation took place, for a political environment pervaded by the presence of Willie Stark could hardly admit the irrelevancy of an artist's alleged subversive background to the abstract images on his canvas. But, there is something else being implied here also in the assertion that such images ridiculed the past venerated by the majority of Americans. It was not merely that the pictures may have seemed ugly, especially in their poor black-and-white reproductions in the popular press, or that many of them were the work of foreigners. They were also somehow undemocratic in that they rejected an immediate accessibility to a shared experience, a satisfying communion between the picture's content and the viewer's expectations. The concentration, tolerance, and patience required for such a communion with these new forms, apparently displayed by the enthusiastic and appreciative cross section of "Advancing American Art" viewers in Prague, were not readily available within the contemporary democratic setting increasingly accustomed to quantitative measurements of value, as Sir Kenneth Clark observed during the same month in which the influential *Look* article

appeared. The "waves of popular indignation," he wrote, "which are occasionally aroused by modern work, and find expression in newspapers which do not normally devote any space to the arts" are actually responses to the potency and vitality which this or that painting suddenly arouses, as if the viewers ". . . all owned shares in an old-fashioned respectable company which never paid, and they didn't complain of that, till suddenly it was found to be issuing a dividend in a currency they couldn't use, [the] fraud [being] aggravated by the fact that a few people, and those often the least deserving, seem to find the new dividend negotiable."[38]

The rage and anger expressed toward the relatively mild State Department exhibit did in fact testify to the potency of advancing modern art in America and, as we have seen, thus contributed to its more widespread acceptance. While it is obviously impossible to find within this discussion of the late forties neat and uniform aesthetic parallels of transition and reorientation, "Advancing American Art" was not an isolated event. Within this general pattern of initial frustration, and even hostility, the issuance of new cultural dividends could only be cashed by going, as it were, to a different and perhaps inconveniently located bank. Were we, for example, within the time-limit of this interesting year of 1947, briefly to shift our attention toward the realm of popular music, we would perceive that there, too, inherited shapes were being challenged and altered. For it was in the spring of that year, within a few weeks of General Marshall's cancellation of the exhibit's tour, that the mysterious and oracular figure of Charlie Parker returned to New York from a California exile, formed a new quintet, and almost single-handedly began to complete the revolution in jazz music which the original five-man group, fronted by the horns of Parker and Dizzy Gillespie, had initiated with their "funny" sounds in the winter of 1944–1945. With its complex figures, counterthemes, polyrhythms, and fresh melodic sound, the new music, called bebop, was "cool," capturing with confidence and, for the initiated, with an almost artless candor the cadences of a not yet quite stable postwar social structure. For this avant-garde subculture, popular music was no longer an experience for ballroom dancing to repeated arrangements in the big band sounds which had evolved in the thirties and which for mainstream America were a crucial symbolic possession to be nostalgically,

but briefly, reclaimed after the war. Rather, jazz was now something impromptu and unrehearsed, to be listened to with intensity and concentration in the intimate lounge settings that were becoming fashionable in the big cities of the East and Midwest; the jazz musician, especially the saxophone player, suddenly became a new cultural hero, and the most expressive, original, and astonishingly improvisational was Parker. The "word from the Bird" through his recordings and club dates was everywhere: his style changed the way every jazz instrument was played, and for the generation absorbed in these new vibrations, the decade was symbolically concluded by the New York opening in December 1949 of the world's largest and most elaborate jazz club. It was named "Birdland," after the powerful and charismatic figure whose vanguard presence had altered a paradigm.

From the end of the war, when the controversial but sensational Parker-Gillespie band had burst onto the New York scene, until the decade was over, traditionalist band-leaders and music columnists alike had viewed the new distribution of notes and musical combinations with dismay and even hostility. It had all "set music back twenty years," said Tommy Dorsey; respected journalists stated that it was "decadent," a "distortion of jazz," its sounds giving the impression of "a hardware store in an earthquake"; and the scholarly, widely read music critic Sigmund Spaeth wrote early in 1948 that the "surrender of jazz to modernism, in the so-called 'Be-Bop' style, threatened to destroy the last vestiges of melodic charm." Indeed, the new directions in popular music during the forties, as seen within the microcosm of Charlie Parker's achievement and their relationship to the subsequent worldwide influence of Afro-American music, form a suggestive parallel in the same decade to the emerging visibility of abstract painting in America and its attainment of an international reputation. This parallel seems particularly relevant in the assessment by Parker's biographer of the essential modernity of his accomplishment: "With perfect taste and intuition he had abstracted the body of music before his time, purging it of anachronisms and irrelevancies, and endowed it with a compelling vocabulary."[39]

This statement obliquely but no less clearly illuminates also the aims and successes of the most influential group of literary theorists during the decade of the forties. For the New Critics, as they were appropriately

called, specifically set out to purge the interpretation of literature of the "anachronisms and irrelevancies" embedded in the layers of historical and biographical judgments which, to them, obscured the essential uniqueness and autonomy of the individual poem or novel. The vision of reality lay abstracted within the work itself and the shared communion between that vision and the reader was not—like that between the viewer and a modern painting—immediately accessible, but was to be achieved through concentration and an intense uninhibited scrutiny of the work's structure and of the variation of meanings to be found within the pattern. And for our subject it would be difficult to find a more relevant example of this stance than Robert B. Heilman's review of *All the King's Men*, which—published during the very months in 1947 when the "Advancing American Art" pictures were being assigned ready made political and aesthetic estimates—emphasized the tragic dimensions of the novel and denounced what Heilman, in retrospect, rightly regarded as the shortsighted, preconceived sociological and contemporary political interpretations to which the work was then being subjected.[40]

But Heilman's essay, besides illustrating the "new" criticism in its close and uninhibited examination of the text, also returns us to that with which we began: the relationship between past and future which the closing passage from the novel (already quoted) addresses. For all his brilliance and pragmatic power, Willie Stark is an "incomplete" man, falling—shot to death—before he can attain what Jack Burden perceives to be necessary for a saving existence: abstracting from the past that which is sustainingly relevant and which can keep a life moving toward its place in the polyform of time, linking together what will be encountered or discovered with what is understood and accepted. This sense of wholeness, the integration of past and future, may indeed be what Heilman identifies as the lost condition defining the plight of modern man—in Warren's words, "the terrible division" of the time in which Willie and Jack live. For us, however, the novel, in addition to this larger transcendent meaning, becomes a particularly revealing metaphor of the period. Set chronologically within the spiritual kinesis of the thirties and published in the first year after the war, Warren's novel may be seen with its theme of incomplete men and disconnection between

past and present as part of that matrix of reorientation, of transition between the decades, which we have been discussing, a time when within many dimensions of the culture the past was in fact being abstracted—some would say, rejected—and translated into forms of expression consonant with a new social and scientific paradigm.

The intersectional kinships among these translations may be obscure, but there would nevertheless appear to be a kind of unyielding autonomy and revelatory expansion of structure and meaning, say, in the harmonious distribution of planes of color within the carefully defined space of an abstract painting by Arthur Dove (Plate 6); in the illustration by the New Criticism of the thematic shapes within the limits of a given poem formed by paradoxical and symbolic suggestions of word and phrase; and in the almost infinite array of improvisations—played at breakneck speed—which a Charlie Parker could develop within the melodic form of a standard tune. As we have seen in part, the absence from these artistic or critical reorientations of familiar appearances or repeated arrangements of sound and interpretation was often resented and, in fact, expressed on allegedly more substantial bases than those underlying the orchestrated derogations of "Advancing American Art" in the early months of 1947. To some, the growing prominence of abstract art lay partly in the superficiality of its technical experimentation, which appealed to a postwar society too fatigued to bear "the greater intellectual demand" required by the full aesthetic designs of representational art; and, because of its lack of pictorial content, which was fundamentally alien to the average, intelligent American's "healthy appetite" for art, its vogue would be short-lived. The whole thing was, in fact, something of a hoax, perpetrated by clever New York dealers who "rigged" the market by identifying modern art as fashionable and thus desirable. And to others, the aesthetic bases of the New Criticism could not be separated from the traditionalistic and aristocratic sociohistorical views of its principal architects, views which were remote from the America of Roosevelt and Truman and indeed from the whole liberal-progressive conception of man indigenous to a democratic society.[41]

Though each of these denunciations probably contains much professional antipathy, both seem to express

an apprehension that something important in the nation's heritage has been lost, or at least damaged, and that it is this diminution which has permitted such radical expressions of the culture to flourish and gain prominence. This perceived sense of loss, always pervasive in periods of transition and reorientation like the forties, was perhaps felt by no one more deeply than by the most famous critic of the "Advancing American Art" exhibit. When confronted by the exaggerated shapes and irregular planes contained in the more abstract pictures, President Truman used the exhibit to derogate the carelessness and lack of coherence he perceived to be characteristic of "so-called modern art," which is, he said:

> . . . merely the vaporings of half-baked lazy people. An artistic production is one which shows infinite ability for taking pains and if any of these so-called modern paintings show any such infinite ability, I am very much mistaken . . . many American artists still believe that the ability to make things look as they are is the first requisite of a great artist. . . . There's no art at all in connection with the modernists, in my opinion.

Unlike Truman's better-known comments made earlier to a group of Washington reporters—that modernist paintings are "ham and eggs art"—and of Kuniyoshi's *Circus Girl Resting*: "If that's art, then I'm a Hottentot,"[42] these judgments were not the extemporaneous, acerbic public wit of a man already looking toward the 1948 elections. Rather, they were part of a carefully written response to Benton's letter which had attempted to explain the purpose of the beleaguered exhibit. And though the president's preferences for representational art are clear enough, his deliberate additional assertion that there is a moral deficiency in those who paint pictures which do not "make things look as they are" suggests his strong concern that it was critical for American traditions of hard work and vigorous forthright values to be reasserted during the difficult postwar period of transition through which the nation was then passing. To President Truman, the Depression and the war had undoubtedly been unifying experiences which had brought the country closer together. And perhaps he too, no less than any of us, regarded art as one of our most immediate mnemonic agents, organizing and stimulating our memories. The new art, largely unpictorial and thus not bringing back the veracity of recognizable appearance,

seemed almost a confrontation with the belief that there was, indeed, a regenerative and redemptive national past which, now that the war was over, would reappear in solid cultural forms.

Possibly these presidential remarks inherently recognized that the early postwar years were, as we have seen, irresistibly releasing a number of transitional signals which posed discernible conceptions of the past against a beckoning future of vigorous promise but potential disarray. And, it is at least arresting to observe that within this pattern, in fact during the very year in which "Advancing American Art" was being conceived and organized, the central vision of America's greatest writer of the century was made clear: a vision of remembered values and their fragile, eclectic existence among the inscrutable forces created, nurtured, and discharged within the internecine stresses of the nation's history. In 1946 none of William Faulkner's novels were in print; and though it is always possible to find in retrospect fanciful rather than revelatory junctions of time and place, it may well be that the literary consciousness which clarified Faulkner's great theme of cultural confrontation could perceive, in the watershed year of 1946 more clearly than before the war, the meaning and scope of that vision.[43]

Compared to the signal beamed from Faulkner's mythical southern county, whose life in its tragic, violent, and disturbing rhythms connects and illuminates two American centuries, the impulse transmitted by "Advancing American Art" was faint indeed. But however faint, it was nevertheless in the late forties part of a larger current of energy seeking proper forms of social expression which would give meaning and coherence to the war and its emerging consequences. Containing an undoubted American validity and identified through the advancing figure in its title with the transition between two stages in the nation's life, the exhibit becomes for us a legitimate image of its time. The singular circumstances of its initiation and reception, of course, charged it with a significance which its artistic content alone could not have created. And of course, too, the very circumstances which helped it to a long life were those which also shortened its career.

# 2

## SALE AND DISPERSAL

*. . . you do as chapmen do,*
*Dispraise the thing that you desire to buy;*
*But we in silence hold this virtue well,*
*We'll not commend what we intend to sell.*
—Paris to Diomedes, Troilus and Cressida

Official discussions of what, finally, to do about the recalled exhibit were perhaps no less cynical than Paris's procedural appraisal concerning the disposition of such tainted Trojan War properties as Helen and Cressida. For "Advancing American Art," even though it would shortly be darkly sequestered in warehouse storage, safe from imparting subversive messages to foreign eyes, was still a most irksome burden to the State Department.

What had begun a few months earlier as a back-page item in the *Journal-American* was by April 4, 1947, a screaming headline: "Marshall Halts World Tour of Red-linked U.S. Art." The accompanying front-page story captured precisely the central complaints of conservative, academic artists that American taxpayers had supported an exhibition of "incomprehensible junk" which included no "truly American, modern and able painters" such as Grant Wood or Thomas Hart Benton. Also, the account was expressed in alarmist and isolationist Cold War rhetoric that the exhibition had been denounced in Congress as "Communist propaganda," with much of its artistic content having "its roots in the alien cultures, ideas, philosophies and sicknesses of Europe."

The dilemma for the State Department only increased when a week later the influential art critic of the *New York Times* reviewed the whole affair, denounced the department for apparently being "intimidated by myopic reactionary attacks," and stated that the closing of the exhibit was "one of the most provocative and shocking developments since America became a cultural force in the world." Predictably, within a month, a full-scale protest was organized in New York City. Sponsored by museum and gallery owners and by such diverse groups as Artists Equity, the Audubon Society, the New York Society of Women Painters, and the Sculptors Guild, the meeting featured speakers who strongly condemned Marshall's proclamation of "no more taxpayers' money for modern art." The groups expressed a collective "sense of shame" for what had happened, and raised the sensitive issue of political censorship of the arts—as stated, for example, by Edith Halpert of the Downtown Gallery: "We will have communism in art if Congress can control what we paint, and free and individual expression is stifled."[1]

For Benton and his associates, keeping the collection intact and under continued governmental ownership was clearly impossible. Somehow, it had to be disassembled, at least some of the initial investment of public funds recovered, and the entire incident laid to a permanent, if uneasy, repose. The solution would require all the unctuous ingenuity and obtuse procedures the department could muster from its considerable resources. And thus, not long after Secretary Marshall had officially ordered the paintings recalled from Prague and Haiti in June, he approved the proposal that the entire collection be declared "surplus property," transferred to the War Assets Administration (WAA), and offered for public sale by the agency under its own bidding procedures. While none of the closely involved constituents were particularly elated over the prospect, with the possible exception of Secretary Marshall, the decision slowly began to move toward implementation. Early in the new year, the art community arranged to have the collection moved from its temporary storage quarters for a short exhibition at the Whitney Museum of American Art for the benefit of all prospective buyers, to begin in May and last until the WAA bidding procedures were completed in mid-June. The exhibit would contain a total of 117 pictures, including the collection of watercolors which the de-

partment had secured under contract with the American Federation of Arts to supplement the seventy-nine oils originally purchased by Davidson.[2]

The sale was announced in an official WAA document (Sales Announcement WAX–5025), which stated that under the Surplus Property Act certain priority categories would be established such as those for tax-supported institutions and war veterans. In retrospect, even with this relatively scant and perhaps obscurely placed information, it seems almost incredible that more bidding activity was not generated toward what promised to be the art bargain of the century. But bids were few. The thirty-six paintings illustrated in this volume were obtained in large measure through the alacrity with which officials at Auburn University responded to the WAA announcement, originally identified by the institution's War Surplus Property Agent. The university received considerable support and advice from members of the Alabama Congressional delegation—especially Senators Lister Hill and John Sparkman and Congressmen George Andrews and Sam Hobbs, none of whom were deterred in their efforts by the controversy surrounding the "Advancing American Art" exhibition. "As you may know," wrote Senator Sparkman to the institution two weeks before the bids were due,

these paintings are now on exhibition at the Whitney Museum of American Art, New York City. I have secured for you from the War Assets Administration a catalog which gives full information as to the procedure to be followed in bidding for the paintings and also a list and description of the paintings. This catalog also contains the proper bid forms which you will note must be submitted, in duplicate, to Associate Regional Director, WAA, P.O. Box 216, Wall Street Station, New York, N.Y. by 10:00 a.m. on June 19, 1948. I am informed that it will be necessary for a separate bid to be submitted on each painting desired. I am also advised that State supported institutions such as Auburn will have priority over private institutions, commercial buyers and the general public. The officials of the WAA inform me that Auburn would be entitled to purchase any of the paintings in the collection at 95% off the fair value— the fair value, of course, will be determined by the WAA. In this connection, in filling out the bid forms, under the column entitled "Amount Bid Per Unit," I am advised that you should indicate "Fair Value." . . . Be

assured that I am eager to do anything I can to help Auburn get the paintings. . . .[3]

The "fair value" of each painting was to be established after all bids were opened, with the 95 percent discount being allowed to qualified purchasers. Along with the American Federation of Arts, Auburn University proposed a fair-value bid on each of the 117 paintings, apparently being followed in this procedure only by a very small number of other institutions of higher education. The University of Oklahoma subsequently was also allowed to purchase thirty-six of the paintings, and so the two universities together secured almost two-thirds of the total collection. "Naturally we are extremely happy and considerably surprised in being so successful," wrote Frank Applebee, Auburn head professor of art, to *Art Digest* editor Peyton Boswell on June 24. And, he continued, though the Department had been notified that it could purchase thirty-four of the paintings, "and possibly 3 or 4 more, since some bidders have been declared ineligible," he confessed, in keeping with the whole bizarre proceeding, that as yet, "we have had no information as to which pictures we were successful in getting"! By the next day, the number available for Auburn to purchase had become thirty-six, and the university agreed by telephone and a subsequent telegram to the fair-value estimate identified by the WAA for the as yet unnamed paintings: $21,453 which, with the allowable 95 percent discount, constituted a total purchase price of $1,072.[4]

The embarrassing facts of the total sale were, of course, duly reported—though not always accurately. Drew Pearson, for example, in his syndicated column of July 17 misread the figures completely, construing the fair value worth of the collection ($79,658) as the actual sale amount, and thus congratulated the State Department on making a profit of over $23,000. Actually, the government's loss was over $50,000 as the original amount paid for both the oil and watercolor groups was $55,800, less the total amount realized through the discounted WAA sale, $5,544. This fact was clarified by *Newsweek* in a full-page text-pictorial article in its July 5 issue whose title, "Retired American Art," ironically recalled the exhibit's once-brave designation and whose content briefly reviewed what was described as the whole "sorry story."[5]

To the more thoughtful commentators, the immediate significance of the story was its depressing revelation that the United States with its emerging worldwide preeminence had no public policy on art free from political interference and governed by authoritative professional standards. Further, it seemed indeed a sorry story that the irresponsible yet widely publicized charges by Congress of artistic incompetence lodged against what was, in fact, an exhibit of fresh and imaginative American expression could only be refuted by a contrived surplus property sale whereby most of the pictures would find their way into publicly supported universities.[6]

Democratic administrations in the 1960s, to be sure, would bridge the legislative chasm between the federal government and the arts. And, in retrospect, one can at least partially understand the cultural conditions under which the strange story of "Advancing American Art" could unfold. Yet it is still astonishing to encounter the simple facts of the exhibit's dispersal as recorded on the sample pages, below, from the WAA sale documents: that an oil by an artist as important in the history of American abstract painting as Arthur Dove could have been purchased for $30; and canvases by modern masters like Georgia O'Keeffe and John Marin for $50 and $100. The arrangement also permitted the sale of what is perhaps the most familiar social-realist painting of the 1940s, Ben Shahn's *Hunger*, for $60; and, even more arresting, the sale of works by perhaps the two most prominent Afro-American painters in the history of American art, Romare Bearden and Jacob Lawrence, for $6.25 (*Mad Carousel*) and $13.93 (*Harlem*)! Today, the Shahn and Marin paintings would be conservatively valued at a thousand times the purchase price; and those by Dove and O'Keeffe would reach in excess of $200,000— as would the celebrated *Circus Girl Resting*, which, incidentally, continued to frequent the imagination of William Benton for years. Being himself an unsuccessful bidder on several paintings at the very WAA sale which he had helped to arrange, Benton was still trying to purchase the Kuniyoshi as late as 1962. At that time his agent, Edith Halpert, wrote to the university that not only would Senator Benton trade the same artist's *Bather with Cigarette* (1924) but he would also, "consider a slight additional payment" since he "is aware of the circumstances under which your painting was obtained at the very special price set under the government regulations."[7]

These illustrations replicate in form and content two of the documents, now in the Auburn University Archives, sent with the paintings by the WAA.

WAA-5 (Extra)
(Revised Oct. 1946)

SALES DOCUMENT (Continuation)

WAR ASSETS ADMINISTRATION

ADDRESS NY City Customer Service Center
Maxwell & Industrial Sts., Bronx 6., N.Y.

DOCUMENT No. 6522060

| CATALOG No. OR DECL'N SERIAL, PAGE AND LINE | PROPERTY DESCRIPTION AND CONDITION | S | UNIT OF M. | NUMBER OF UNITS SOLD | UNIT SALES PRICE | SALES AMOUNT | DO NOT WRITE IN THIS COLUMN |
|---|---|---|---|---|---|---|---|
| | Sale No. D1-4513  Program 38-7597 Loc. Whitney Museum of American Art | | | | | | |
| 3294599 04-08 | 700.00                    700.00 SCC 73-99900        Cond:Good O.A. #217 Painting      Oil Title    "Circus Girl Resting" Name of Artist  Kuniyoshi, Yasuo Type of Surface  Canvas Stretcher  23 3/4" x 39" O/A Size w/Frame  43" x 33" Outer Frame    Wood Outer Frame Finish  Painted Item #46 | | ea | 1 | Less 95% | 2000.00 100.00 | |
| 3294599 05-01 | 1200.00                  1200.00 SCC #73-99900       Cond:Fair O.A. #217            Tear in top                            of Canvas Painting     Oil Title   "Seascape" Name of Artist   Marin, John Type of Surface  Canvas Stretcher  30" x 23½" O/A Size w/Frame  39"x33" Outer Frame Finish  Painted | | ea | 1 | Less 95% | 2000.00 100.00 | |
| 3294599 05-05 | 1000.00                  1000.00 SCC 73-99900        Cond:Good O.A. #217 Painting      Oil Title       "Small Hill Near                    Alcade" Name of Artist  O'Keeffe, Georgia Type of Surface  Canvas Stretcher Overall Size    24½ x 20" Outer Frame    Metal Outer Frame Finsih   Metal Item #56 | | ea | 1 | Less 95% | 1000.00 50.00 | |

6/26/48

ADDRESS

**WAR ASSETS ADMINISTRATION**

NYC CUSTOMER SERVICE CENTER
INDUSTRIAL & HASWELL STS., BX., N.Y.

DOCUMENT No. 6522061
WAS-(3)

| SOLD TO | SEND DELIVERY TO |
|---|---|
| Alabama Polytechnic Institute<br>Auburn,<br>Alabama | WAA<br>40 Wall Street,<br>New York, N. Y. |

| SHIP TO | SHIPPING INSTRUCTIONS--ROUTING AND DELIVERY |
|---|---|
| Same as above | |

| SALE DATE | SOLD BY--REGION | SOLD BY--DISTRICT | TYPE DISPOSAL | TYPE BUSINESS | TERMS | |
|---|---|---|---|---|---|---|
| 6/25/48 | 2 | 1 | 04 | Educational | Tax Supported<br>Credit | $30.00 |

| SALE NO. | SALES SECTION | PROGRAM | SALESMAN | CASH RECEIPT VOUCHER | W'HSE LOT No. | CONTRACT/P.O. No. |
|---|---|---|---|---|---|---|
| DI-6816913 | 38 | 38-7597 | Selzer | --- | --- | 1 - B - 2 |

| PROPERTY LOCATION | OWNING AGENCY--ADDRESS--PLANCOR No.--DECLARATION No. |
|---|---|
| U. S. Dept. of State<br>Washington, D. C. | U. S. Dept. of State<br>Washington, D. C. |

| CATALOG No. OR DECL'N SERIAL, PAGE AND LINE | PROPERTY DESCRIPTION AND CONDITION | S | UNIT OF M. | NUMBER OF UNITS SOLD | UNIT SALES PRICE | SALES AMOUNT | |
|---|---|---|---|---|---|---|---|
| 1  3294599 | 400.00D1-6913    400.00<br>SCC 73-99900    Cond: Good<br>O/A 217<br>Painting: Oil<br>Title: "Grey Greens"<br>Name of Artist: Dove, Arthur<br>Type of Surface: Canvas<br>Stretcher: 28" x 20¼"<br>Overall Size w/Frame: 30¼"<br>                  x 22½"<br>Outer Frame: Wood<br>Outer Frame Finish: Unpainted<br>Item #22<br><br>       LAST ITEM<br><br>   xxx      xxxxx<br><br>Send Remittance to:<br>  War Assets Administration<br>  Box 216, Wall St. Station<br>  New York 5, N. Y.<br>Attn: Chief Collection Section<br><br>"This Document covers a sale made to<br>a Public Benefit Buyer:"<br>  Established Fair Value  $600.00<br>  Percentage Discount Allowed  95% | | ea | 1 | 600.00<br><br>Less 95%    30.00<br><br><br><br><br><br><br><br><br><br><br><br>This Contract Includes:<br>S. D. 6522061<br>     6522060 | | |
| | TAC 600.00    Total | | | 1 | | | |

| PRIORITY OR VETERAN'S CERT. No. | | | SALES TAX TOTAL AMOUNT | 30.00 | |
|---|---|---|---|---|---|

But by midsummer of 1948, when the paintings began to move from the Whitney to such far destinations as Seattle, Washington; Athens, Georgia; Auburn, Alabama; and Norman, Oklahoma, the stage which had briefly enclosed the drama of "Advancing American Art" had begun to clear and the actors themselves dispersed. For example, Benton would leave the State Department in the fall and, before his Senate career began, become ambassador to UNESCO; LeRoy Davidson had already been appointed to the art history faculty at Yale University and would follow an academic career over the next thirty years at the University of Georgia, Claremont, and later at UCLA; and Representative Busbey would fail in his 1948 bid for reelection. All of the furore seemed hardly to have affected the careers of the exhibit's artists, unless they were enhanced by it, and most went on without interruption to win prizes and assume a wide range of commercial commissions. The artist with perhaps the longest subversive pedigree in the entire show, Anton Refregier, for example, having executed only recently some striking murals for Cafe-Society Uptown, was moving in 1948 toward completing his large-scale murals on the history of California for a public building in San Francisco. This project was already beginning to draw criticism of the "Advancing American Art" intensity from conservative organizations and the Hearst press, which called many of the representations un-American and Communistic propaganda. Some of the artists, such as Kuniyoshi and Shahn, because of their earlier leftist associations, would continue to have their work criticized in a similar manner well into the fifties, but both would have their professional reputations well documented in 1947–1948 through major one-man shows, respectively, at the Whitney Museum and the Museum of Modern Art.[8]

In addition, of course, pictures by many of the "Advancing American Art" painters would be on European exhibit during 1947–1948 in the "American Industry Sponsors Art" show, especially in Rome and Venice—in a country, as Lloyd Goodrich lamented, which "our government has been fervently wooing," but where, because of the State Department art disaster, the first American exhibit in years had to be organized and supported by private sources. Ironically, the pictures for this important international exhibit had been selected by the much-maligned LeRoy Davidson. And Shahn, one of

the central figures in the disaster, whose work only a few months earlier had been derided in the press and by Congress as alien to the American image, would complete in his stark expressionist style the striking cover illustration for a major summer issue of *Fortune* magazine devoted to this very subject of the struggle in Cold War Italy between capitalism and communism. But among the numerous intersections between "Advancing American Art" and the wider life of the culture, perhaps the most ironic of all was created through the publication by *Look* magazine, less than a year after its "Your Money Bought These Paintings" subtly criticized the exhibit, of a poll designed to select the ten best painters then working in the United States. The painters were identified through responses from a wide range of art critics, leading curators of painting collections, and museum directors. As it turned out, all of those chosen had been represented in the State Department show, with the five receiving the most votes each having painted one of the seventy-nine oils chosen by Davidson: John Marin, Max Weber, Yasuo Kuniyoshi, Stuart Davis, and Ben Shahn. The selected artists were themselves polled, and essentially chose the same group as the directors and critics;

they also placed Marin at the top, included as well Shahn, Kuniyoshi, Weber, Davis, and Grosz, and added from the "Advancing American Art" group Philip Evergood. No American-scene painters or members of the emerging Abstract Expressionist group were represented and the poll essentially reaffirmed from authoritative sources the temperate and judicious nature of the judgments which had originally given form to the short-lived exhibit.[9]

We still, to be sure, have much to learn about the meaning and subsequent effect on the national life of the half-decade following the war, whose creative energy and array of cultural confrontations within a changing society now often seem obscured by the rhetorical density of domestic politics and Cold War statecraft. These confrontations, as we have seen in the introductory section of this book, would be both sustained and heightened in the fifties and would achieve there an uncertain resolution. But their emergence in the late forties was truly consonant with the time, for as Arthur Miller observed at the end of the decade, the potential disaster and the apprehension "in being torn away from our chosen image of what and who we are in this world" is now "per-

haps stronger than it ever was."[10] He was writing, of course, about the individual plight of another Willy, this one a salesman—and, like Robert Penn Warren's magnetic demagogue, an incomplete man residing within the modern dilemma of securing a coherent assimilation of past and present.

Like the exhibit called "Advancing American Art," both Willy Stark and Willy Loman assumed their created form under our democratic sky in the immediate postwar years. And both have now become for us figures representative of their time and their place. Certainly it is not possible to claim for the exhibit itself, despite its unique and rather dramatic history, the same kind of central location in the crowded postwar resurgence which witnessed so many responses, both political and aesthetic—some of them with long histories themselves—to an image of America which seemed after the war irretrievably altered. But in its cluster of associations, it clearly was part of a cultural front whose outposts appeared, as we have seen, in such seemingly contradictory settings as the bop scene and the halls of the 80th Congress. In a sense, the exhibit under discussion issues a kind of minority report about the conditions of that front; and, over the intervening forty years, as we have become increasingly aware of the value of minority reports, it is proper that we recall it now: with wry amusement, perhaps, in the hope that some of the more strident and hysterical elements of that time will not return; but with appreciation, too, for the reassuring configuration it does offer between past and present. For "Advancing American Art" is, after all, not a historical document or a political happening, but a collection of pictures: in her repose, the circus girl still smiles her enigmatic smile; the hand of the hungry still reaches out; the anxious mother and child stand frozen still in their apprehension of the urban world; and a harmony of unexpected shapes and colors still defines for us a seascape and a late afternoon. In its own small way, "Advancing American Art" helped to keep the culture moving, for though the rage has long since subsided, thousands of university students and public patrons now find its pictures bridging the decades in a quiet, strangely evocative way, best recalled perhaps by Shakespeare's words in *Measure for Measure*: "Painting, sir, I have heard say, is a mystery."

# 3

---

# THE ARTISTS AND THEIR WORKS

The Auburn State Department Collection may be, in many respects, the most significant assemblage of contemporary art of the 1930s and 1940s in the South. The thirty-six paintings in the collection were acquired by Auburn University in 1948, from a public sale of the State Department's "Advancing American Art" exhibit. Every painting in the collection is reproduced in this volume, and each work is accompanied by a commentary.

In spite of the importance of many paintings in the collection, and of the artists who painted them, the nature and range of the collection are relatively unknown except to scholars and museum personnel. Together with the history and interpretation of the "Advancing American Art" exhibit in chapters 1 and 2, this display and discussion of individual paintings in the Auburn segment of the exhibition should define further the place and meaning of "Advancing American Art" in our postwar culture.

Chance played a large part in the apportionment of the "Advancing American Art" paintings to successful bidders, and Auburn was fortunate in getting an excellent cross section of the original exhibit of seventy-nine oils purchased by LeRoy Davidson, and of the thirty-eight supplemental watercolors procured by the American Federation of Arts for use when the total exhibit would be divided and sent to Europe and Latin America respectively. Auburn's thirty-six paintings represent almost one-third of the total "Advancing American Art" exhibit of 117 pictures.

An exhibit of the original seventy-nine oils purchased by LeRoy Davidson for "Advancing American Art" took place at New York's Metropolitan Museum of Art, opening on October 4, 1946. Adverse criticism of this exhibit from Congress and the news media eventually caused the combined exhibition of oils and watercolors to be recalled from touring and sold at auction. Of the seventy-nine oils in the Metropolitan exhibit, Auburn secured twenty-four, and of the forty-seven artists who created the offending oils, twenty-three are represented in the Auburn collection, three of them by watercolors—Romare Bearden, Irene Rice Pereira, and Gregorio Prestopino. The twelve watercolors purchased by Auburn in the 1948 sale were selected according to the same criteria as the oils, except that the latter are more overtly avant-garde.

The objective of the commentaries is to introduce the reader to the artists and their works, and to identify the particular qualities in the paintings that caused them to be selected for "Advancing American Art." LeRoy Davidson, as a State Department officer, was charged with the responsibility of assembling an exhibit which would represent the "newest developments in American art." The charge did not specify avant-garde art, and some of the selections in oil and watercolor are not avant-garde. Nevertheless, an avant-garde attitude was implied, and most of the "Advancing American Art" exhibit consisted of paintings which were considered new and experimental in the United States, even though they were influenced by European movements that date from the earliest years of this century.

It was inevitable that "Advancing American Art" should reflect a European influence. Paris had been the center of artistic activity until World War II, and it was customary for serious American painters to go there for periods of study. In addition, a large number of European artists emigrated to the United States, or spent the war years here. Of the thirty-one artists represented in the Auburn Collection, twelve were born outside the United States.

Early exposures of the American public to modern European art occurred at the New York galleries of Alfred Stieglitz (known as "291" and "An American Place") beginning as early as 1908, and at the 1913 International Exhibition of Modern Art, where the avant-garde art of Europe and America was first exhibited on a large scale

in the United States. The latter is now better known as the Armory Show because it was held in New York City's 69th Infantry Regiment Armory.

European art is pertinent to this discussion only to the degree that it affects the paintings in the Auburn Collection. The fact that the State Department paintings were influenced by European art movements does not rob them of originality. The artists concerned acquired new ideas and motivations from Europe just as European artists had drawn inspiration from the arts of Africa, the Orient, and the Pacific islands. The real value of European influences lay in the fact that they encouraged American artists to see their own environment and creative potentials in a new way. The State Department paintings were not simply extensions of European art; it would be more accurate to say that artists in the United States adapted European creative currents to American situations.

The major European art movements went through several phases, each of which represented new ways of thinking. The American painters who drew on them often selected a single phase to exploit, and some painters combined the influences of more than one move-ment. The influences were often slight or superficial, but they were sufficient to identify the paintings selected for "Advancing American Art" as employing concepts that were new or experimental in the United States. Perhaps the most important factor to be considered is the degree of originality displayed by the individual artist in adapting new ideas from abroad.

For purposes of this writing, the several European movements which constituted modern art may be resolved into two major modes of visual representation: abstract (intellectual) and expressionist (emotional). Within this classification, the movements having the greatest effect on the State Department paintings were Cubism, Fauvism, and Expressionism. An examination of the Auburn Collection calls for some brief definitions of contemporary art, and of movements affecting the paintings concerned, in order to establish a frame of reference for the commentaries which accompany each painting.

Collectively speaking, all art considered modern must exist as a creation in its own right and not as an imitation of something else; a painting may concern nature but not imitate the appearance of nature. The

illusion of infinite space resulting from the use of Renaissance perspective is avoided; the image should remain on the picture plane (the surface of the canvas), and spatial depth should be a controlled element of the composition.

Subject matter in modern art is usually made subordinate to the means of expression employed by the artists to arrive at their pictorial objectives. Abstract art assumes that a painting may be visually interesting and exciting simply because it presents an effective composition of the expressive means employed by the artist: color, line, light and dark, form, texture. The term abstract means to draw away from; and, in pure abstraction, no residue of subject matter remains. An abstraction may also be created with no subject matter in mind. *Composition*, by Irene Rice Pereira (Plate 28) is such a work. It is a visual improvisation using geometrical themes. However, the word abstract is customarily used to designate any art where the subject is distorted or subordinated so as to place emphasis on the structural properties of the work.

Most of the abstract work in the Auburn Collection owes a debt to Cubism, the French art movement associated with Picasso. Analytical Cubism (c. 1907–1912) viewed subject matter with the mind more than with the eye. The subject being depicted was often fragmented and displayed from several points of view simultaneously. Abstract structure was expressed at the expense of other pictorial elements, but, because the subject was never completely eliminated, Cubism was not pure abstraction. However, it was abstract in the broad sense in which the term is now used. Cubist theory has lent itself well to personal interpretation in both Europe and America. Two examples of abstract work in the Auburn Collection having a Cubist influence are *Still Life in Red, Yellow and Green*, by Byron Browne (Plage 2) and *Clam Diggers*, by Karl Knaths (Plate 10). Neither artist studied in Europe.

Expressionist art subordinates the subject to the emotional responses which it arouses in the artist. The way the artist feels about the subject becomes more important than the subject itself. Intensification of feeling is expressed by distortions of form, heightened color, and exaggerated changes of scale and contrast. Ben Shahn's

painting *Hunger* (Plate 14) depends on anatomical distortions rather than words to project the message of a hungry child. The representation of reality is distorted to communicate an inner vision—nature is transformed rather than imitated.

Fauvism (1905–1908) was the first organized expressionist movement in Europe. It began in France, with Henri Matisse as leader of the group. The Fauvists liberated color by using it nondescriptively: rather than simulating the natural color of the subject, they strengthened colors to full intensity, sometimes applying paint directly from the tube. Areas of color were often dissociated from the subject and used independently as a compositional element. Similarly, forms were distorted and exaggerated for emotional emphasis in drawing, and contrasts of light and dark were intensified. The Fauvist movement was basic to both Cubism and Expressionism. *Rock Crabs*, by George Constant (Plate 4), reveals Fauvist influences in the artist's use of nondescriptive color, forceful brushwork, and distorted forms.

Expressionism was primarily a central European movement involving Germany and Austria. It was broken into phases represented by three groups: *Die Brucke* (The Bridge), 1905–1914; *Der Blaue Reiter* (The Blue Rider), 1911–1914; and *Der Neue Sachlichkeit* (The New Objectivity), 1920s.

Members of The Bridge group were influenced by Fauvism, and the expressive means used by the two groups were essentially the same. Both movements relied on bold, nondescriptive color and distorted forms to express emotional intensity. However, paintings produced by the respective groups differed in choice of subject matter and in national characteristics. The Fauve painters chose traditional subjects—landscapes, figure pieces, interiors, and still life. Their paintings, especially those of Matisse, were usually intended to provide visual pleasure. Painters from The Bridge group were inclined to choose subjects which were expressive of the Germanic concern for inner meanings that transcend obvious appearances in nature and human behavior. *Fascist Leader*, by Philip Evergood (Plate 7), has characteristics associated with The Bridge painters in that it comments on a social movement by portraying subjective response rather than by depicting objective reality. The symbolic

use of skeletal figures to express attitudes of the artist also has precedent in German Expressionist art.

Since the most prominent member of The Blue Rider group was Wassily Kandinsky, who is credited with painting the earliest pure abstractions, it is not surprising that the group should have had an abstract orientation. Lyonel Feininger, represented in the Auburn Collection, was a Cubist when he was invited to join The Blue Rider group. His watercolor painting *Late Afternoon* (Plate 8), in which a red sea reflects a trapezoidal sun, has qualities derived from both Cubism and Expressionism. Another Cubist painting having Expressionist properties is *Mad Carousel*, by Romare Bearden (Plate 1), where the up-and-down motion of figures on horseback is suggested by dynamically placed planes of color. Even the title is expressive. Perhaps the most typically Expressionist painting in the Auburn Collection is *News From Home*, by Paul Burlin (Plate 3) in which the traumata of World War II are expressed with symbolic figures and orgiastic revelry. Strong nondescriptive color and extreme formal distortion also identify the work as Expressionist.

The New Objectivity was motivated by World War I and its effects on civilization, especially that of the German people. It was a violent form of social comment, and one of the art techniques employed was super-realism (not to be confused with Surrealism) in which minute detail is exaggerated to the point where the effect is unreal. Magic Realism, which appeared in the United States in 1943, was influenced by this movement; Louis Guglielmi's painting *Subway Exit* (Plate 22) is an excellent example of this painting style. One of the founders of The New Objectivity was George Grosz, who later emigrated to the United States and was represented in the original "Advancing American Art" exhibit.

Abstract or Expressionist works dominated the "Advancing American Art" exhibit, with Expressionism being the more prevalent influence. It is also evident that abstraction and Expressionism have many characteristics in common and that some paintings will show evidence of both influences. Some classifications of the paintings in "Advancing American Art" represent a point of view of the artist rather than an art movement—Social Realism, for example, which attracted many of the best Expressionists in the exhibit; *Harlem*, by Jacob Lawrence (Plate 25), is a visual comment on segregation in New York City.

The Auburn Collection has a good representation of the types of experimental work being done in the United States at the time that the "Advancing American Art" exhibit was assembled. Davidson overlooked some of the younger artists who later distinguished themselves as Abstract Expressionists, but it is also true that Abstract Expressionism had its roots in the intellectual and emotional attitudes of the period which "Advancing American Art" represents.

Some of the painters whose work appears in the Auburn Collection, such as Arthur Dove, Georgia O'Keeffe, and John Marin (Plates 6, 13, 12), have continued to grow in stature during the last forty years, securing more firmly their places in the history of American art. Jacob Lawrence and Romare Bearden are perhaps the two most significant Afro-American painters yet to emerge in our national art. Others whose work appears in this collection, of course, are names now less familiar to curators and historians of art than they might have been in 1946 when they were chosen for the ill-fated exhibit. The paintings of each artist represented, however, contain in one way or another elements of that modernity and advancing style or technique which Davidson was trying to display in the exhibit as a whole.

# ADVANCING AMERICAN ART

## THE AUBURN COLLECTION

# LIST OF PLATES

27. *In the Hills* (1944) by Herman Maril

28. *Composition* (1945) by Irene Rice Pereira

29. *Donkey Engine* (Undated) by Gregorio Prestopino

30. *Thomas Rhodes* (Undated) by Boardman Robinson

31. *Neapolitan Nights* (1946) by Mitchell Siporin

Note: All measurements for the following paintings are given in inches. Height precedes width.

# Plates and Commentaries

**1**

*Mad Carousel*
by Romare Bearden
Watercolor on paper
22½″ × 30¾″
Undated

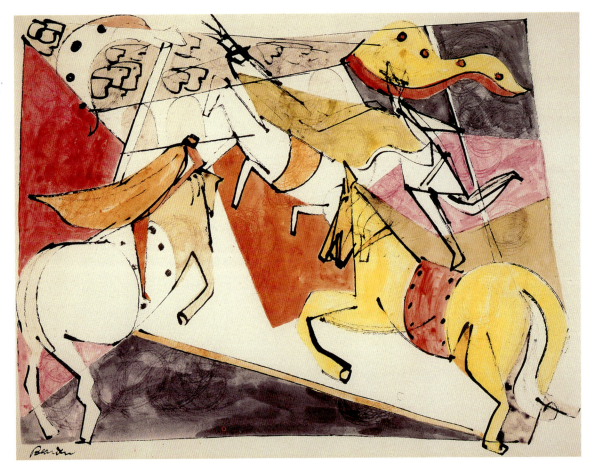

**ROMARE BEARDEN** (1914–1988) was born in Charlotte, North Carolina and later moved to Harlem with his family. One of two Afro-American artists in the "Advancing American Art" exhibit, he held a degree in mathematics from New York University (B.S., 1935) and studied philosophy and art history in Paris at the Sorbonne (1951). His earliest art interest was cartooning but, while studying at the Art Students League in the mid-thirties, he was encouraged by George Grosz to pursue an art career seriously. After a period of Social-Realist painting, he became interested in Cubism. This interest is evident in *Mad Carousel*, where subject matter is reduced to geometricized linear descriptions, planes and lines of direction. A one-man exhibit at the Samuel Kootz Gallery in New York (1945), followed by a Museum of Modern Art purchase, established a reputation for Bearden which has grown with succeeding years. His watercolor *Mad Carousel* is a departure from his favorite themes of jazz and folk music, urban and rural Negro life. Bearden was an intellectual as well as an exceptional artist, and held honorary doctorates from five major educational institutions in the United States. He was a member of the American Institute of Arts and Letters.

**2**

*Still Life in Red, Yellow,*
*and Green*
by Byron Browne
Oil on canvas
23¾″ × 28″
1945

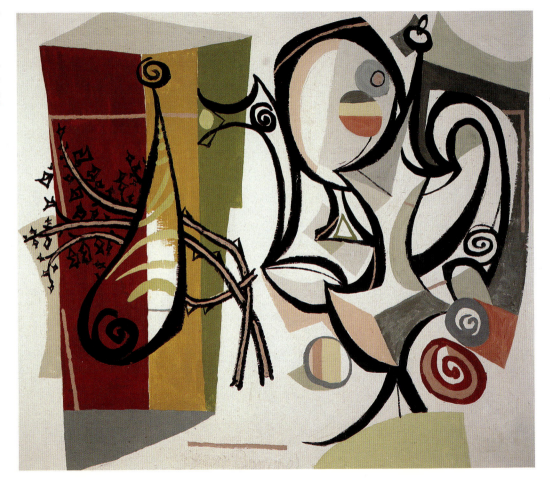

**Byron Browne** (1907–1961) was born in Yonkers, New York. He became identified as an abstract artist in 1935 when he was included in the Whitney Museum's exhibit "Abstract Art in America," along with Irene Rice Pereira and Karl Knaths (also in the "Advancing American Art" exhibit). Browne's painting *Still Life in Red, Yellow, and Green* reflects the influence of European abstractionists in the way that color and form are dissociated and used as independent compositional elements. The dominating image consists of decorative figurations of heavy black lines describing nature-related forms. Flat-color shapes break in and out of the linear figurations freely, allowing negative space to penetrate the composition. Fernand Léger frequently employed a similar technique but Browne never studied with Léger; his art training was obtained at the National Academy School of Fine Arts (1924–28) under C. W. Hawthorne and Ivan Olinsky, neither of whom was an abstractionist. He was a charter member of the American Abstract Artists association (1936).

**3**
*News from Home*
by Paul Burlin
Oil on canvas
23″ × 29″
1944

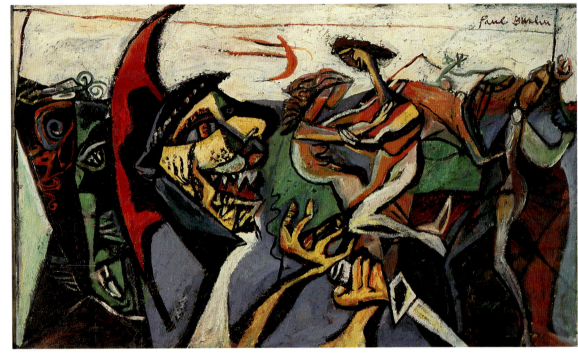

**PAUL BURLIN** (1886–1969) was born in New York City. He is quoted in Ralph Pearson's *Experiencing American Pictures (Harper,* 1943, p. 181) as saying that "Art . . . may take its inspiration from externals and realities, but the painter must evolve new forms to contain his symbols. . . . Only thus can he truly interpret the world he did not create." This statement is a good summary of Expressionist attitude. Burlin did, indeed, evolve new forms and symbols to express the American scene. However, as his inner world became progressively more private, both subject matter and titles became less comprehensible to viewers of his paintings. *News from Home,* painted in 1944, symbolizes Burlin's reactions to World War II and its attendant emotional trauma. The helmet and sword make Mars, the Roman god of war, an easily recognizable symbol, but it is left to the observer to determine the significance of the figures in the background which appear to be dancing. Like Ben-Zion, Burlin was self-taught in art. He was included in the landmark Armory Show (New York, 1913), where avant-garde European and American art was first exhibited in the United States on a large scale.

**4**
*Rock Crabs*
by George Constant
Oil on canvas
20″ × 16″
Undated

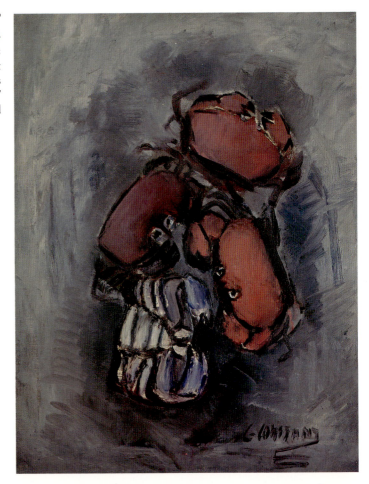

**4a**
*Seated Figure*
by George Constant
Watercolor on paper
12″ × 7¼″
Undated

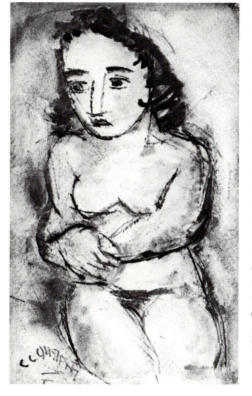

**GEORGE CONSTANT** (1892–1978) was a native of Greece. His art education was obtained at Washington University (1912) and at the Chicago Art Institute School (1914–18). He painted successfully in a number of styles ranging from realism to pure abstraction, thereby illustrating one of the problems encountered by critics attempting to categorize contemporary artists: the fact that their styles may change radically several times during their art careers. When the "Advancing American Art" exhibit was being organized, George Constant's work was nonfigurative, a fact which places the painting of the two undated works in this collection at an earlier time. The watercolor, *Seated Figure*, could be a study belonging to any period, but the deft handling of paint and the purposeful distortion of natural forms in the oil *Rock Crabs* indicate that it belongs to a former period when Constant was interested in Fauvism, an early form of Expressionism which emerged in France just after 1900 with Matisse as the leading figure. The Fauvist movement took shape about 1905 and lasted until 1908, at which time George Constant would have been between thirteen and sixteen years old. The fact that Constant experimented with Fauvist ideas after he became a mature artist is indicative of the lasting influence of the short-lived European movement.

**5**
*Plane Production*
by Ralston Crawford
Oil on canvas
28⅛″ × 36¼″
c. 1946

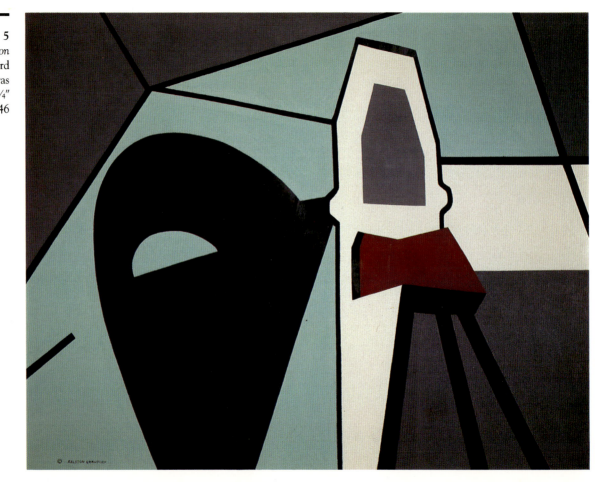

**Ralston Crawford** (1906–1978) was born in St. Catharine (Ontario), Canada, but his art training and career as an artist are identified with the United States, where he studied at the Otis Art Institute, Los Angeles (1926–1927) and the Pennsylvania Academy of the Fine Arts (1927–1930), later becoming a prominent member of the Precisionist group. He studied in Paris during 1932–1933. His early works were a compromise between realism and abstraction—almost photographic renderings of subject matter simplified to the degree that the general effect was abstract. His work in the 1940s began to emphasize flat-color shapes combined with linear elements. These shapes and linear statements were sometimes geometric and sometimes free forms. Crawford often used recognizable shapes around which he developed an abstraction, but he also created pure abstractions which simply externalized his feelings about the subject. *Plane Production* is a painting of the latter type. It is an abstract composition suggestive of airplane parts. The work is undated, but its characteristics indicate that it was painted about 1946. During World War II Crawford was chief of the visual presentation unit of the Air Force Weather Division. Since the preparation of weather charts and related types of visual communication often involves the use of symbols and flat pattern concepts, it is possible that the abstract tendencies appearing in Crawford's work by 1941 were reinforced by the Air Force experience.

**6**
*Grey-Greens*
by Arthur Dove
Wax emulsion on canvas
20″ × 28″
1942

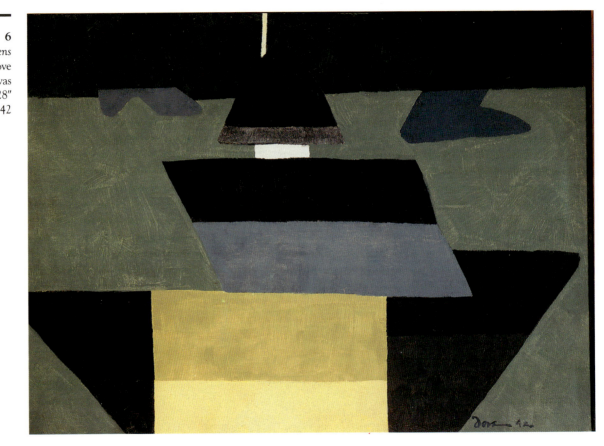

**ARTHUR DOVE** (1880–1946) was one of our pioneer abstract artists. He studied art at Cornell University with Charles Furlong, graduating in 1903. Subsequently, he became a successful illustrator and cartoonist in New York. Dove went to Paris for further art studies in 1907 and returned in 1909 with an understanding of modern art movements in Europe. However, the type of abstraction he developed in the United States was a lyrical symbolism essentially his own. Dove felt that he could symbolize visually the forces of nature, and even sounds, with equivalent plastic elements (form, shape, color, texture, space, light and dark) which he extracted from nature and assembled in meaningful relationships. Titles of the abstractions often gave a clue to the subject. His paintings symbolizing nature date back to 1910, and are among the earliest abstractions painted in the United States. Auburn's painting *Grey–Greens* is typical of the works done in the last years of Dove's life. It is painted with a wax emulsion which he began using in 1936, and neither the painting nor the title makes reference to tangible subject matter. It is a nonobjective abstraction with geometrical elements rather than an abstraction which interprets nature.

**7**
*Fascist Leader*
by Philip Evergood
Oil on canvas
20″ × 25″
1946

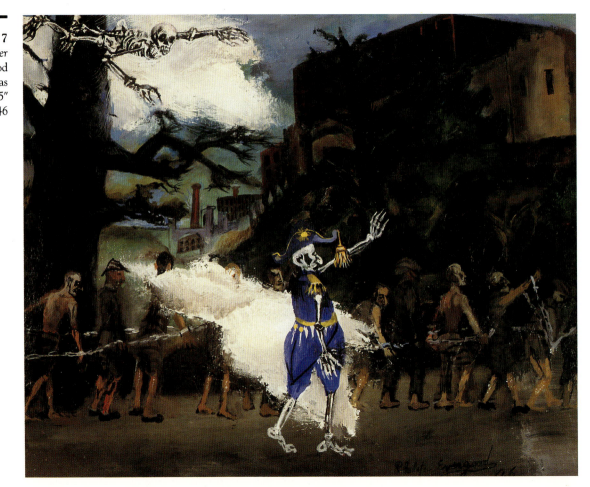

**PHILIP EVERGOOD** (1901–1973) engaged in the struggle against social injustice both as a painter and as an activist in left-wing, anti-fascist organizations. In *Fascist Leader*, his flair for caricature and biting satire is effectively revealed in the pompously uniformed skeletal figure of the leader reviewing a line of fettered prisoners against a background of smokeless factories while a skeletal guardian angel (or Angel of Death) is suspended above. Since fascism glorifies the state at the expense of individuals and controls all levels of economic activity, the allegorical message of the painting might be that the wages of fascism is death. Evergood was born in New York City but received his formal education in England, where he also studied later at London's Slade Art School (1921–1933). In addition, he studied painting at the Art Students League, in New York (1923–1924) and at the Academie Julian in Paris (1924–1926). In 1931 he settled permanently in the United States. The Depression was at its height, and the attendant social and economic problems affected both Evergood and his work, much of which took the form of social protest. However, the respect he commands in the art world is based on his ability as an artist rather than a propagandist.

**8**
*Late Afternoon*
by Lyonel Feininger
Watercolor and ink on paper
12¼″ × 18⅝″
1934

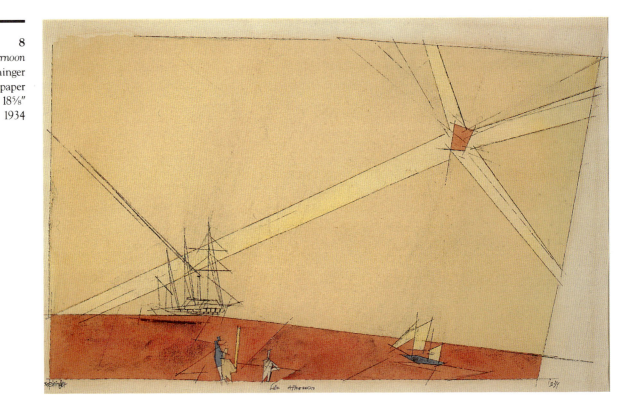

LYONEL FEININGER (1871–1956) was born in New York of German parents with whom he emigrated to Germany in 1887. As a result, he was exposed in his formative years to the European movements on which the art of this century is founded. Forsaking the career of a violinist, for which he was being trained, he studied art in Hamburg, Berlin, and Paris from 1893 to 1907. He began painting seriously in 1907, and his early works show influences of Cubism. However, by 1913 he was exhibiting with pioneer German Expressionist groups. His work fuses elements of both movements. Feininger was an instructor and later artist-in-residence at the Bauhaus between 1919 and 1933. In 1937, his work was declared degenerate by the National Socialists and he returned to America. Feininger saw in nature and man-made objects an inner architectonic structure which he made a visible part of the picture. Thus, the observer sees the subject through a spatial framework which reveals the compositional relationships of the pictorial elements. Such a framework is evident in *Late Afternoon*. The technique is derived from fragmented Cubism, where nature is taken apart and put together in another form, but Feininger's love of nature often impelled him to retain the character of the subject in an almost illustrative way. The date of execution indicates that *Late Afternoon* was painted in Europe.

**9**
*Worksong*
by Robert Gwathmey
Oil on canvas
29¾″ × 36″
1946

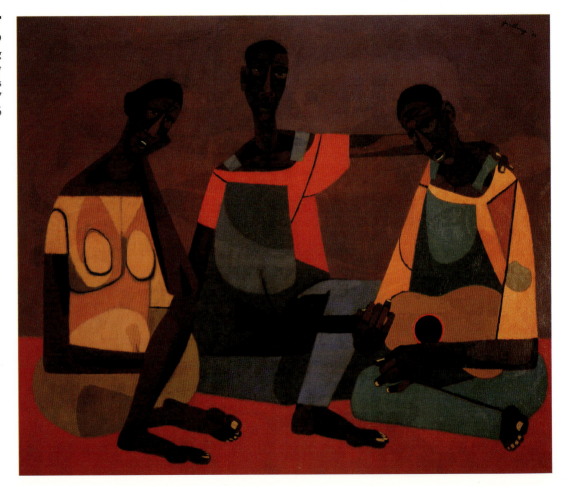

ROBERT GWATHMEY (1903–1988) was born in
Richmond, Virginia, and in his twenties studied at both the
Maryland Institute College of Art (1925–1926) and the
Pennsylvania Academy of Fine Arts (1926–1930). He is a
southerner whom critics have sometimes classified as a zeal-
ous crusader for social causes. Though he may have been at-
tracted by social themes, his works appear to be designed to
please the eye and satisfy a creative urge, rather than to propa-
gandize. It seems likely that, along with other southern art-
ists of his generation, he simply saw blacks and their
activities as good painting material and identified with them
as part of his childhood environment. *Worksong* has more of
the qualities of a genre painting with Cubist overtones than
a protest against the working conditions for minority groups.
Gwathmey is best known for his easel paintings, but he once
executed a mural commission for the US Post Office at Eu-
taw, Alabama; and, in 1939, was a winner in the govern-
ment-sponsored Forty-Eight States Mural Competition.

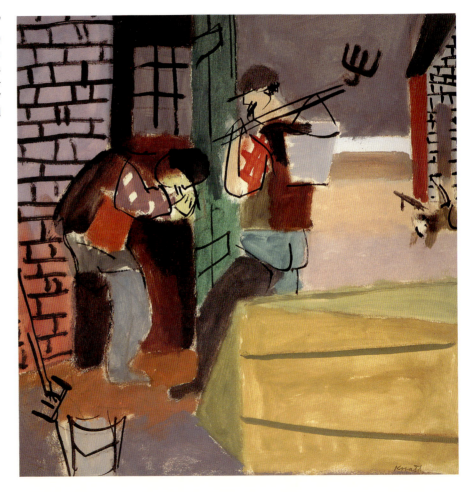

**KARL KNATHS** (1891–1971) was a native of Wisconsin, but much of his work, like *Clam Diggers*, is associated with Cape Cod. His art training was received at the Chicago Art Institute School (1912–1916), but Knath's lifelong interest in Cubism began when he saw modern European paintings at the Chicago version of New York's 1913 Armory Show. *Clam Diggers* is an excellent example of the artist's ability to reduce nature to pictorial elements—juxtaposition of static and dynamic forms; interplay of flatness, volume and space; textural differentiations and contrasts of somber and clear color. Spatial depth is controlled without perspective, and the image stays on the picture plane. The characteristics and possibilities of the watercolor medium are exploited in both concept and technique, evidence of which appears in the bold, highly simplified patterns and textures, as well as the impulsive use of the brush for linear descriptions. The painting is unusual in that Knaths seldom used figures in his compositions. Use of the watercolor medium coupled with directness of technique contributes to the spontaneous quality of the work. Knaths held an honorary Doctor of Fine Arts Degree from the Chicago Art Institute School, and was a member of the National Institute of Arts and Letters.

**11**
*Circus Girl Resting*
by Yasuo Kuniyoshi
Oil on canvas
39¼″ × 28¾″
Undated

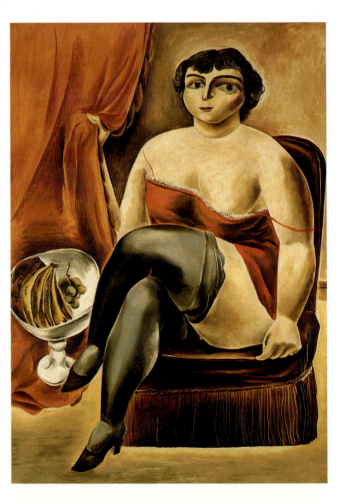

**YASUO KUNIYOSHI** (1889–1953) was Japanese by birth, but received his art education in the United States and Europe. His undated *Circus Girl Resting* has qualities that repel some and attract others, depending on whether the observer is looking for a beauty queen or a provocative work of art. Though his circus girl is neither lovely nor temperate, her attraction for lovers of modern art will not fade, because Kuniyoshi has made her interesting rather than conventionally beautiful. His style is difficult to classify; he has been called a Romanticist, an Expressionist, and a Surrealist. The intentionally naive distortions of anatomy and perspective in *Circus Girl Resting*, as well as the unorthodox shading and flesh color, also suggest that he was influenced by American primitive painters. Kuniyoshi's stylistic medley has impressed many critics and collectors. One of the impressed collectors was William Benton, the State Department officer responsible for the "Advancing American Art" exhibit. Later publisher and board chairman of the *Encyclopaedia Britannica*, Benton controlled the Britannica's collection of contemporary American paintings. He bid for several of the State Department pictures, but was not successful, and, for several years after, tried to acquire *Circus Girl Resting*. At one point he offered to trade as many as three of the Britannica's paintings for the Kuniyoshi, and to include as a bonus the following: a set of the *Encyclopaedia Britannica; Britannica Junior* (a children's encyclopedia); *The Eventful Years* (a four-volume history of the war decade 1936–1946); and a copy each of the *Britannica World Atlas* and the 1948 edition of *Britannica Book of the Year*. The offer was declined.

**12**
*Seascape*
by John Marin
Oil on canvas
23½″ × 30″
1940

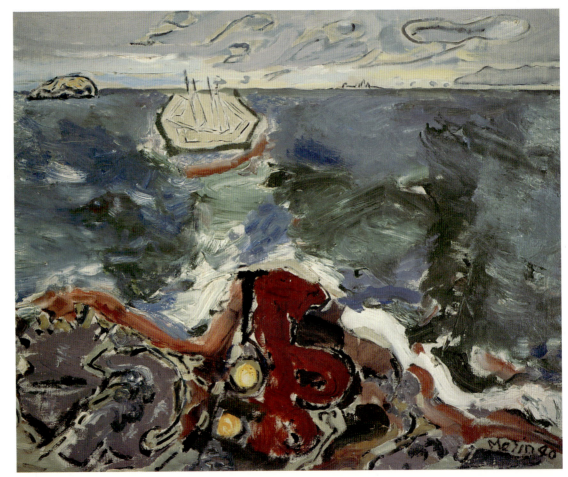

JOHN MARIN (1870–1953) was a patriarch among artists represented in the "Advancing American Art" exhibit. His recognition as a modernist did not occur until 1912, when he initiated a series of abstract and highly Expressionistic watercolor paintings of subjects in New York City. These watercolors depicted the skyscrapers and crowds typical of urban scenes, but with a technique which distorted subject matter in order to express feelings of tension and movement associated with city life. One of Marin's works was included in New York's Armory Show of 1913. He continued to work successfully in watercolor, extending his subject matter to the Maine Coast and later to New Mexico. In about 1928, he became seriously interested in oil painting, and much of the spirit of his watercolors carried over into his oils. His watercolors usually had ample areas of white paper showing around the image and appearing within the image as negative space, and he used bare canvas in the same way for his early oils. However, his later oils filled the picture format in the accepted way. He also exploited the greater textural activity which oil paint affords, and his brushwork developed an almost calligraphic quality. In working from nature, Marin's compositions favored large forms—sky, sea, mountains, plains—against which he played smaller forms to create spatial tensions and textures. These characteristics are visible in *Seascape*, painted in 1940. The big spatial divisions are introduced as shoreline, sea, and sky; the smaller forms as clouds, distant rock, boat, and textured patterns in the foreground. It is difficult to associate Marin with one school. He was both Expressionist and abstractionist, and his work had a romantic affinity with the forces of nature. His last paintings had qualities in common with Abstract Expressionism. Marin was born in Rutherford, New Jersey. He worked as an architect in the early 1890s, then studied at the Pennsylvania Academy of the Fine Arts in Philadelphia (1899–1901), and at the Art Students League, New York (1901–1903). He studied and traveled in Europe from 1905 to 1910, but did not embrace modern art until his return to the United States.

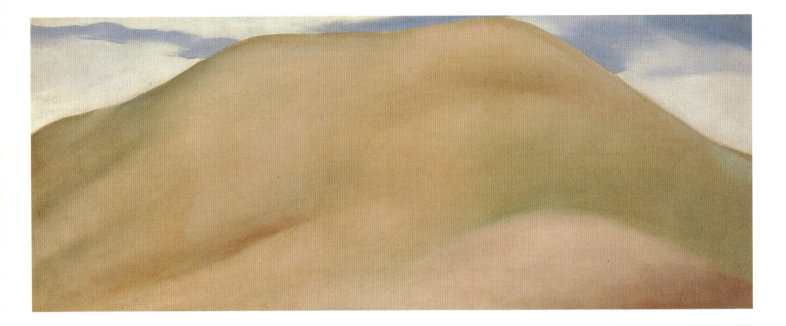

**13**
*Small Hill Near Alcade*
by Georgia O'Keeffe
Oil on canvas
10″ × 24¼″
Undated

**GEORGIA O'KEEFFE** (1887–1986) is considered by many the most important woman artist America has produced. All of her art training was received in the United States. *Small Hill Near Alcade*, her unsigned, undated painting in the Auburn Collection, cannot be considered more than a study or sketch. It contains the characteristically feminine forms encountered in her works, but lacks the imaginative quality, color sensitivity, and conceptual brilliance of her significant paintings. However, another important characteristic of her work is present—that of simplifying nature progressively until the essence of the basic forms is revealed. Her process of simplification serves to intensify, rather than obscure, the character of the subject portrayed. This type of abstraction became known in the 1920s as "Precisionism," "Cubo-Realism," or "The Immaculate Style," but Georgia O'Keeffe's works are too diverse to bear a single label. She was born in Sun Prairie, Wisconsin, and attended the School of the Art Institute of Chicago (1904–1905). She studied at the Art Students League, New York (1907–1908), and at Columbia University with Arthur Wesley Dow (1916) whose interest in oriental art had a lasting influence on her work. Though she was widely travelled (Europe, Mexico, USA, Peru, Japan) she never studied abroad. O'Keeffe held a number of honorary degrees and was a member of the National Institute of Arts and Letters. When she died in 1986, at age 98, Jack Cowart, the National Gallery of Art's curator of twentieth-century art, in an Associated Press release announcing her death, called her a "national treasure."

**14**
*Hunger*
by Ben Shahn
Gouache on composition
board
39″ × 25″
Undated

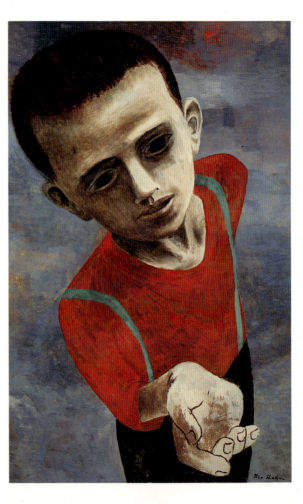

BEN SHAHN (1899–1969) was one of the most distinguished American artists of his period. He did significant work as a muralist, photographer, printmaker, painter, illustrator, and writer on art. The wrath of Congress was provoked when the CIO's Political Action Committee used Ben Shahn's *Hunger* for a poster after it had been purchased by the State Department for the "Advancing American Art" exhibit. This sort of publicity was not new for Shahn, who had gained, in some quarters, both recognition and notoriety in the early 1930s with a group of paintings based on the Sacco-Vanzetti case. Idealist and reformer, Shahn used his brush as a weapon against what he believed to be social injustice. He was fundamentally an Expressionist, but much of his art was concerned with social comment in its application. *Hunger* is probably the most publicized painting in the Auburn collection. Shahn was born in Lithuania, but came to the United States with his family in 1906 and grew up in Brooklyn, where he was apprenticed to a commercial lithographer (1913–1917). He attended New York University and the City College of New York as a biology student (1919–1922). Trips to Europe in 1925 and 1927 introduced him to the paintings of Cézanne, which had a strong influence on his work. Shahn was a mural assistant to Diego Rivera in 1933 on the ill-fated Rockefeller Center frescoes, and like Rivera was opposed to much abstract art not comprehensible to the public—yet both artists are considered influential modernists. Shahn's works after World War II lost their emphasis on social concerns.

**15**
*Mother and Child*
by Nahum Tschacbasov
Oil on masonite
23⅞″ × 20″
1945

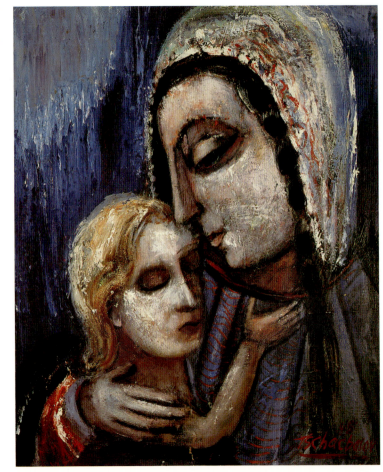

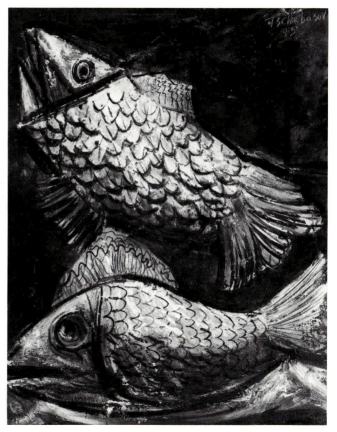

**15a**
*Fish*
by Nahum Tschacbasov
Oil on canvas
20″ × 15¾″
1945

NAHUM TSCHACBASOV was born in 1899 in
Baku, Russia, on the Caspian Sea. After coming to the US
and settling in Chicago he had a business career as an ac-
countant and efficiency expert. He started painting in 1930,
but his work did not begin to sell until 1943. An early client
was Joseph Hirshhorn. Tschacbasov studied at the School of
the Art Institute of Chicago and with Léger and Gromaire
in France. His most important influences were Cubism,
Chagall, and the folk art of his native Near East. His work
moved through several styles, including social satire, but his
paintings lost their satirical qualities after 1940 and began to
depict more pleasant and positive aspects of the environ-
ment, such as *Fish* and *Mother and Child*. *Fish* is a spirited
rendering of a commonplace subject made more interesting
by decorative brush drawing similar to that encountered in
folk art, while *Mother and Child* shows a strong influence of
Byzantine religious art in both stylistic treatment and use of
color.

**16**
*Clown and Ass*
by Karl Zerbe
Encaustic on canvas
24″ × 32″
Undated

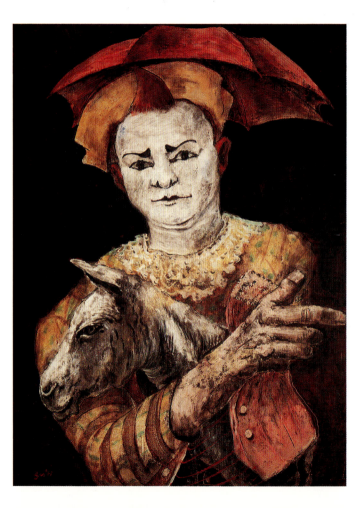

**KARL ZERBE** (1903–1972) was born in Germany and received his art education there. After travel in Europe and Mexico, he came to the United States in 1934 and acquired citizenship in 1939. He taught at the Fine Arts Guild in Cambridge, Massachusetts (1935–1937) and at the Boston Museum School (1937–1955). Zerbe developed a type of Expressionism that relied on symbols and influenced other artists in the Boston area. His work does not have the same visual impact as Surrealism, but he used many devices employed by Surrealists such as juxtaposition of contrary images, exaggerated changes in scale, and placement of objects in an unnatural environment. These occur in *Around the Lighthouse*. His interest in the expressive use of surface textures led him to experiment with encaustic and wax emulsions. The two undated paintings *Clown and Ass* and *Around the Lighthouse* both employ wax media. Zerbe's liking for the symbolic and surreal made the clown a natural choice as a painting subject, for the clown is a symbol of freedom from the conscious controls of reason and convention. After leaving Boston, Zerbe taught at Florida State University (1955–1972).

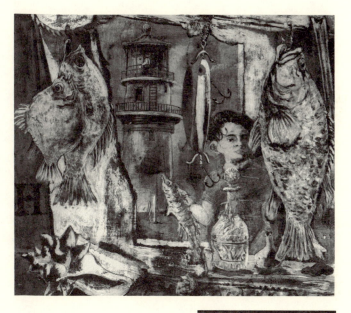

**16a**
*Around the Lighthouse*
by Karl Zerbe
Encaustic on Canvas
30¹⁄₁₆″ × 36″
Undated

**17**
*The Strangled Tree*
by Ben-Zion
Oil on canvas
26⅞" × 36"
Undated

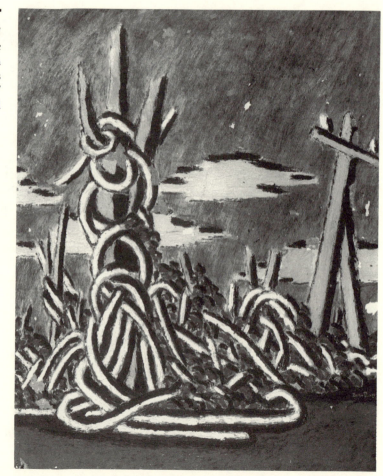

**BEN-ZION**, born in Russia in 1897, is a poet, Old Testament scholar, and painter. He is a self-taught artist. After traveling in Europe and Mexico, he came to the United States in 1920 and has been a citizen since 1936. His paintings apparently impressed LeRoy Davidson because four were purchased for the "Advancing American Art" exhibit: *Perpetual Destructor*, *Thistles*, *The Strangled Tree*, and *End of Don Quixote*, with the latter two being obtained for this collection through the war assets sale. The titles of the four paintings have the calamitous ring of Old Testament prophecies, and it is evident that Ben-Zion is an Expressionist who communicates pictorially through symbolic images. His images are boldly conceived and the practice of surrounding major forms with heavy black lines gives his work a primitive forcefulness. *The Strangled Tree* projects a message of creative growth overpowered, and *End of Don Quixote* may symbolize Ben-Zion himself. He and Don Quixote both represent idealists struggling to cope with a materialistic civilization. *The Strangled Tree* is awaiting restoration; flaking in the background areas is visible in the reproduction. Both paintings are undated.

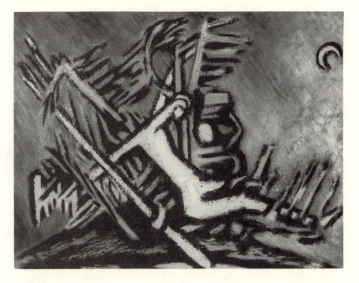

**17a**
*End of Don Quixote*
by Ben-Zion
Oil on canvas
30″ × 25″
Undated

**18**
*Under Stiff Rearguard Action*
by Julio de Diego
Oil on masonite
15¾″ × 22″
1942

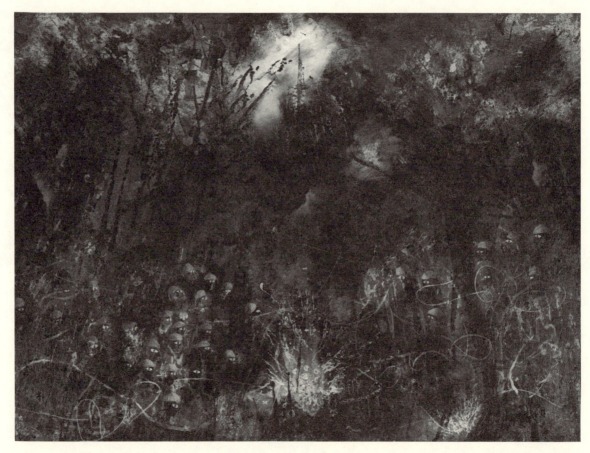

**JULIO DE DIEGO** (1900–1979) who was born and educated in Spain, inherited some of Goya's interest in the fantastic. The work of this Expressionist artist often involves myths, symbols, and obscure titles. *Under Stiff Rearguard Action* is a good example, for the observer is left in doubt as to the exact meaning of the painting. Bursting shells and barbed wire indicate a military operation, but no weapons are visible among the masked figures peering at an exploding mine. Rearguard, spelled as one word, implies resistance to sweeping social forces. Has de Diego created a fantasy suggesting that the sweeping social force we must resist is war itself? De Diego was not alone in his preference for obscure titles, and it is understandable that a Congress which was already hostile toward abstract art might have been further provoked by this and other obscure but suggestive titles in the "Advancing American Art" exhibit; for example, *A Dark Thought*, by Werner Drewes, and *News From Home*, by Paul Burlin. Both titles lend themselves to a wide variety of interpretations.

**19**
*The Ravine*
by Joseph de Martini
Oil on canvas
35½" × 27⅜"
Undated

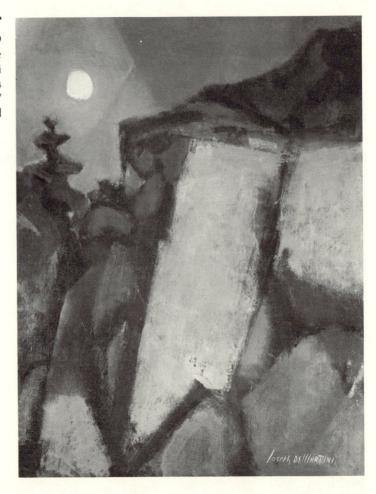

JOSEPH DE MARTINI (1896–1984) was born in Mobile, Alabama and studied at New York's National Academy School of Fine Arts. His art career is identified with New York City and the Atlantic coast, where *The Ravine* and a number of canvases having similar qualities were painted. The dreamlike qualities of *The Ravine* are reminiscent of Albert Ryder, the nineteenth-century American Romanticist. This Expressionist work projects the impression that one is viewing a revelation of natural forces rather than a description of nature. It is a visual expression of the artist's feeling about nature. His work in other fields of painting—portraiture, for example—is of an entirely different character and reveals little influence of any school or individual artist. De Martini was the recipient of a Guggenheim Foundation Fellowship in 1951, and taught at the University of Georgia (1952–1953).

20
*Gaiety in Times of Distress*
by Werner Drewes
Oil on canvas
19⅞″ × 30″
1943

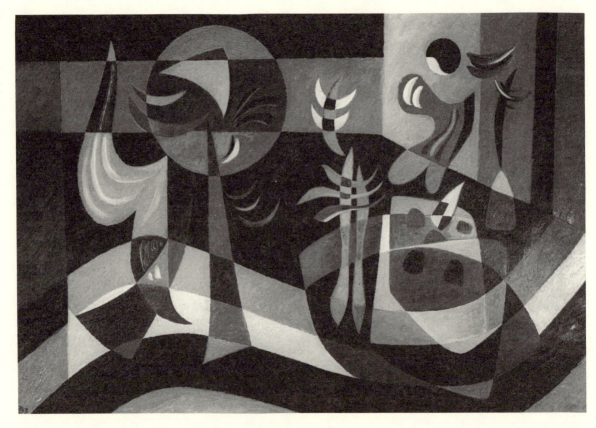

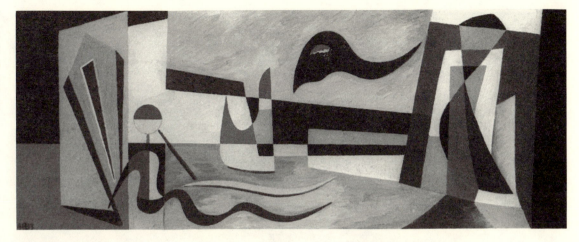

**20a**
*A Dark Thought*
by Werner Drewes
Oil on canvas
13″ × 33″
1943

**WERNER DREWES** (1899–1985) was born in Germany. He studied painting at the Bauhaus in Weimar (1921–1922) under Joseph Itten and Paul Klee and at the Bauhaus in Dessau under Wassily Kandinsky and Lyonel Feininger (1927–1928). He had previously studied architecture. Drewes migrated to the United States in 1930 and became a citizen in 1936. He was a cofounder of the American Abstract Artists association (1936), and taught at a number of educational institutions in this country. His paintings in the Auburn Collection are abstract, but the expressive qualities of *A Dark Thought* caused it to be one of seven paintings selected for reproduction in *The Republican News* (a Republican party newsletter), and later in *Newsweek* magazine (October 25, 1947) under the heading "Art for Taxpayers." The painters concerned were labeled "Fellow-traveler" artists. Actually, Drewes was a fugitive from National Socialism in Germany. In *Gaiety in Times of Distress*, bouncing, biomorphic forms are contrasted with harsh angularities to create the uneasy state implied by the title.

**21**
*Home*
by William Gropper
Oil on canvas
16¹⁄₁₆″ × 20¼″
Undated

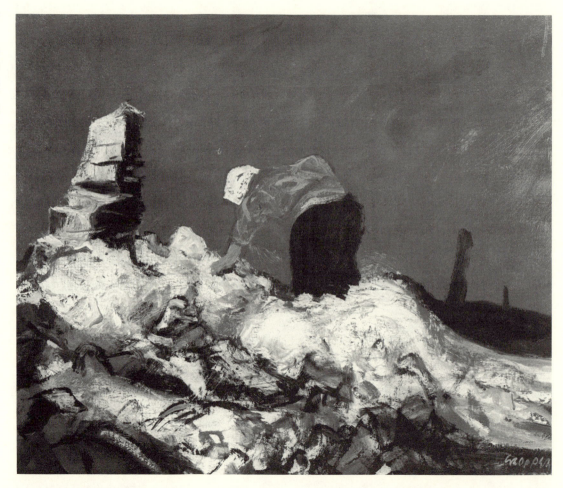

**WILLIAM GROPPER** (1897–1977) was born in New York City. He was an illustrator, cartoonist, and painter. In spite of his distinction in these fields, he was an unusual choice for the "Advancing American Art" exhibit because neither his graphic work nor his painting represented something new from the standpoint of concept or technique. By his own admission, he was more interested in life than in art movements. His painting methods were essentially those of Robert Henri and George Bellows, with whom he studied at New York's Ferrer School (1912–1915). Both Bellows and Henri were realists who had no interest in social concerns. For Gropper, however, realism was a means of fighting injustice in society and hypocrisy among its leaders. Gropper was a champion of the underprivileged and his paintings usually had social themes which were humanitarian rather than propagandistic. His painting *Home*, which shows a poverty-stricken old woman returning to a bombed-out dwelling, reflects both his anti-war and humanitarian attitudes. The subject matter suggests that this undated work may have been painted shortly before the State Department acquired it.

**22**
*Subway Exit*
by Louis Guglielmi
Oil on canvas
29⅞ × 28″
1946

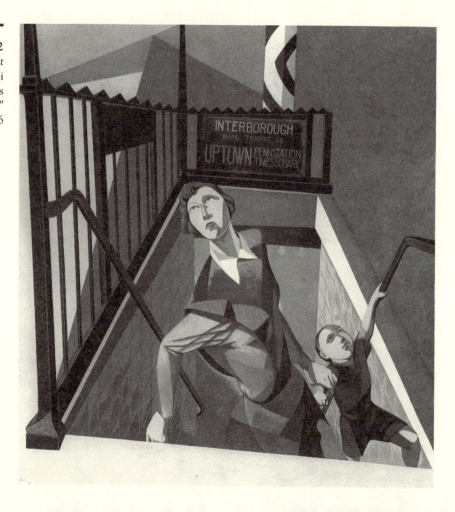

Louis Guglielmi (1906–1956) emigrated with his parents from Cairo, Egypt, to the United States in 1914. He received his art training at the National Academy School of Fine Arts, New York (1920–1925). This academic background served as a sound basis on which to develop his later interests in Surrealism and Magic Realism because both presuppose sound training in drawing and art fundamentals. (Magic Realism is a form of realism in which commonplace objects or events are made to take on an aura of strangeness, fantasy, or mood not inherent in the object or situation). A mother and child emerging from a subway is a very commonplace event that would usually excite no emotional response, but Guglielmi's painting *Subway Exit* projects a sense of doom—a feeling that the mother expects an impending calamity to strike. The technique is one of meticulously designed realism in which subtle distortions or exaggerations of perspective, form, color, and lighting create a psychological dimension not apparent in the subject. Since Guglielmi's themes often manifested pronounced social concerns, the term "Social Surrealism" was sometimes applied to his work of this period.

**23**
*Landscape*
by John Heliker
Watercolor on paper
14⅞″ × 18¹⁵⁄₁₆″
1941

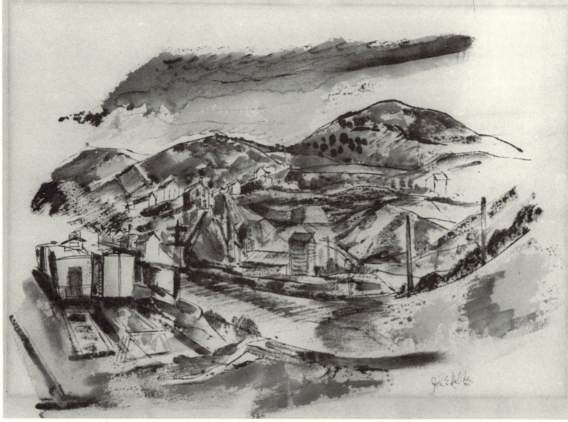

JOHN HELIKER was born in 1909 in Yonkers, New York, and received his art training at the Art Students League in New York City (1927–1929). One of a number of artists in the "Advancing American Art" exhibit who were also educators, he taught at the Colorado Springs Fine Arts Center and was a professor of painting at Columbia University. He holds a D.F.A. degree from Colby College. Heliker is a strong draftsman who handles both landscape and figure painting well and is at home with either watercolor or oil media and techniques. His painting *Landscape* is a watercolor with a visible drawing structure that is part of the composition. Heliker's work before the mid-forties was realistic; *Landscape*, which appears to be a study made on location, falls into that category. After the mid-forties, Heliker's work became progressively more abstract in both landscape and figure painting, and he is now thought of primarily as an abstractionist.

**24**
*Bank Night*
by Frank Kleinholz
Oil on masonite
23⅞″ × 31″
Undated

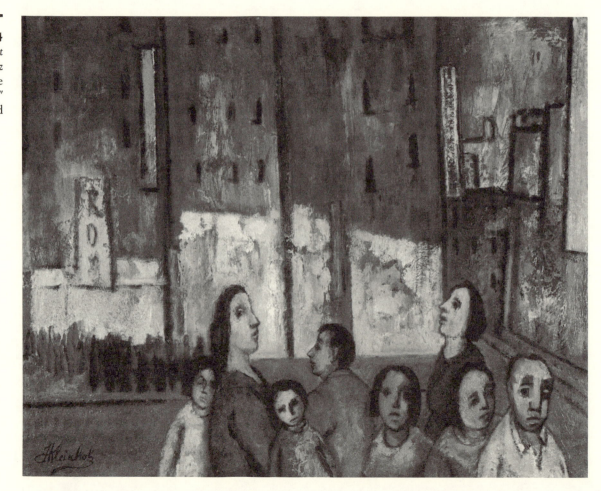

**FRANK KLEINHOLZ**, who was born in 1901, holds an LL.B. degree from Fordham University and left a law practice to devote himself to painting. He is also a writer, and it is ironic that LeRoy Davidson should have chosen for the "Advancing American Art" exhibit the work of an artist who would later write an article entitled "Abstract Art Is Dead" (*American Dialogue*, July 1964). In fact, it is surprising that Davidson should have chosen the Kleinholz painting at all, because the city scenes for which he had become well known are not conceptually or technically innovative. Though *Bank Night* is less of a visual report than many of his paintings, it can hardly be called a strongly Expressionist work, and it lacks the protest elements associated with Social Realism. None of the foregoing keeps *Bank Night* from being a sound piece of painting.

**25**
*Harlem*
by Jacob Lawrence
Watercolor on paper
28″ × 21″
1946

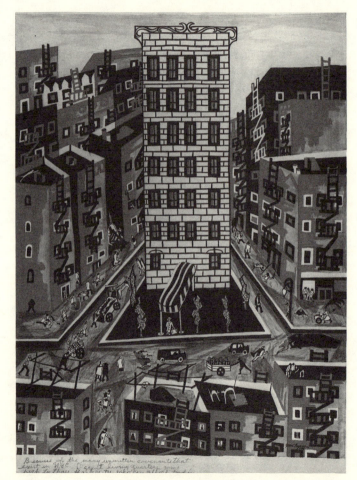

**JACOB LAWRENCE** was born in 1917 in Atlantic City, but moved to Harlem as a young adolescent. His earliest art training took place in a Harlem settlement house. By dint of pure talent, intelligence, and drive he has become America's best-known Afro-American painter and a distinguished artist and educator. Most important museums own his work, and any survey of American art would be incomplete without him. In the lower left corner of Jacob Lawrence's watercolor *Harlem*, he has made the following notation: "Because of the many unwritten covenants that exist in N.Y.C. decent living quarters come high to tho[se] Harlemites who can afford to pay." Like most of Lawrence's early work, the painting has social-message implications. However, his paintings were seldom vitriolic, as the works of many Social Realists of that period were. Instead, they produce the impression that they are simply well-designed statements of fact, and this apparent simplicity increases their effectiveness. From 1932 to 1939 Lawrence studied with the black painter Charles Alston. During that period he also painted under the WPA Federal Art Project (1934–1938) and studied with Anton Refregier under a scholarship at the American Artists School (1937–1939). Lawrence later taught at Joseph Albers' Black Mountain College (1947) and on the faculties of Pratt Institute (1956–1971) and the University of Washington, with frequent engagements as visiting artist at other schools. He is a member of the National Institute of Arts and Letters.

**26**
*Rock Forms and Boats*
by Jean Liberté
Gouache on composition
board
20½″ × 26⅜″
Undated

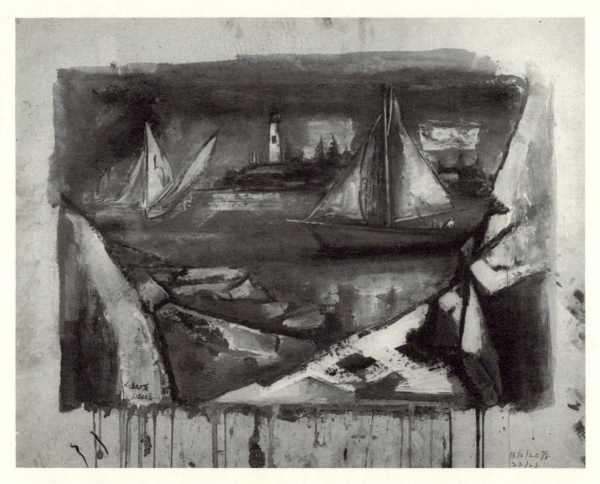

JEAN LIBERTÉ (1896–1965) was born in Italy, but emigrated to New York City, where he studied at the Cooper Union Art School, the Art Students League, and the Beaux-Arts Institute of Design. A successful painter of landscapes, seascapes, and figure pieces, he worked mainly in oil, using the traditional practice of underpainting, then glazing and scumbling. He never painted directly with oil colors. His undated *Rock Forms and Boats* is a direct painting in gouache, a medium similar to poster paint which allows none of the visual effects for which Liberté is noted. In this work Liberté did not adjust his concepts to exploit the working qualities of gouache, a fact which suggests that *Rock Forms and Boats* is a preparatory sketch for an oil painting. A notation in the right corner of the composition board indicates that the margins around the image were to be matted off for framing, but the sheet is reproduced in its entirety because it was felt that the marginal accidentals provide insight into the working habits of the artist.

*In the Hills*
by Herman Maril
Gouache and ink on paper
12⅟₁₆″ × 18⅟₁₆″
1944

HERMAN MARIL, born in 1908, is a Baltimore native whose work reflects a deep interest in American life. He was educated at the Baltimore Polytechnic Institute and Maryland Institute College of Art, but he arrived at his painting concepts—particularly with regard to clarity of form and elimination of nonessentials—through studies of modern French, early Italian, and Renaissance art. These concepts or principles are evident in his gouache painting *In the Hills*, probably executed during military service. Before World War II, Maril was considered one of the more promising of the younger painters. While in service he painted a number of works in small format using gouache and ink because it was a practicable way of working under the circumstances. These were, for the most part, visualizations for larger works in oil to be undertaken after release from military duty. However, *In the Hills* is a strong painting in its own right. Indications for the proposed mat opening are retained because they represent a compositional decision by the artist.

**28**
*Composition*
by Irene Rice Pereira
Ink and gouache on paper
16″ × 11¾″
1945

Irene Rice Pereira (1907–1971) is the only artist in the "Advancing American Art" exhibit whose work is abstract in the sense that it makes no reference to nature, time, or place. *Composition* is a purely intellectual creation, devoid of emotion or retinal reporting. It is the closest approach to pure abstraction in the collection presented here. The idea that such an art may be beautiful goes back to ancient Greece, as the following excerpts from a statement by Socrates in the *Philebus* of Plato (Section 51c) will demonstrate: ". . . I will try to speak of the beauty of shapes, and I do not mean, as most people would think, the shapes of living figures, or their imitations in paintings, but I mean straight lines and curves and the shapes made from them, flat or solid, by the lathe, ruler and square. . . . These are not beautiful for any particular reason or purpose, as other things are, but are always by their very nature beautiful, and give a pleasure of their own . . . and colors of this kind are beautiful, too, and give a similar pleasure" (Quoted by Alfred Barr, *Cubism and Abstract Art* [Harvard University Press, 1986] p. 14). This statement by Socrates has become a credo for abstract painters and sculptors, especially for geometric abstract artists such as Irene Rice Pereira. She was born in Chelsea, Massachusetts, and studied fashion design before attending the Art Students League (1927–1930), in New York City. In 1931 she studied with Amédeé Ozenfant in France and became interested in his theories of functionalism. Pereira taught in the design laboratory of the WPA Federal Art Project (1935), where she developed an interest in geometric abstraction which influenced her work for the remainder of her life.

**29**
*Donkey Engine*
by Gregorio Prestopino
Gouache on paper
22⁵⁄₁₆″ × 29³⁄₈″
Undated

**GREGORIO PRESTOPINO** is a second-generation Italian, who was born in New York's Little Italy in 1907. His first art training was received at a settlement house and his precocity resulted in a scholarship for study at the National Academy School of Fine Arts. Settlement-house art training in the New York area was apparently effective; Jacob Lawrence, younger by ten years and also represented in the present collection, started his art training under the same circumstances. By coincidence, the early works of both artists have striking similarities—simple, direct forms, strong pattern, expert use of space, and an indebtedness to Oriental art. Both preferred aqueous media and neither was interested in deep space. Prestopino's later works retain many of these characteristics. The city, its workmen, and the machines and vehicles they operate have been his special interest. A strong feeling for the subject infuses vitality into his work. In the undated gouache painting *Donkey Engine*, the personality of the engine dominates the human figures and their surroundings.

**30**
*Thomas Rhodes*
by Boardman Robinson
Gouache on masonite
16″ × 12″
Undated

**BOARDMAN ROBINSON** (1876–1952) was born in Nova Scotia and spent part of his youth in Wales. He distinguished himself in the United States as an illustrator, muralist, easel painter, and educator. His portrait of Thomas Rhodes does not represent the "newest development in American Art," which, according to Assistant Secretary of State William Benton, the "Advancing American Art" exhibit was organized to do. Nevertheless, it is an interesting and unusual portrait by a prominent American artist and educator. Robinson came to the United States in 1894 and received his first art instruction at the Boston Normal Art School (1895–1897). He studied in Paris (1898–1904). After returning to the United States, he became art director of *Vogue* magazine and subsequently political cartoonist for the New York *Tribune*. During World War I, he was an artist-reporter in Eastern Europe and Russia. His mural commissions include the Rockefeller Center, in New York (1930), and the Department of Justice, in Washington (1939). After moving to Colorado in 1930, he taught at the Broadmoor Art Academy and continued working as an illustrator and easel painter. Like many artists of his generation, he drew no line between the fine arts and the arts of commerce.

**31**
*Neapolitan Nights*
by Mitchell Siporin
Gouache on illustration
board
23¾″ × 18¾″
1946

**MITCHELL SIPORIN** (1910–1976) was born in New
York City, but obtained his art education at the School of
the Art Institute of Chicago after moving to that location.
He painted murals under the WPA Federal Art Project, and,
in 1939, won a national competition to paint seventeen fres-
coes in the new Post Office building, St. Louis, Missouri.
His prewar easel paintings reveal a concern for human values
which he often directed toward social comment. In World
War II, Siporin was stationed in Italy with the Fifth Army
Historical Section as a roving reporter artist, and was deeply
impressed by the experience of seeing a great classical cul-
ture destroyed by modern warfare. His painting *Neapolitan
Nights* reflects this experience. The anti-Fascist graffiti, the
crippled veteran playing the accordion, the unprotected
child, and other symbols give this painting a story-telling
quality once associated with his murals.

# NOTES

## PREFACE

1. See especially Jane DeHart Mathews, whose important article "Art and Politics in Cold War America," *American Historical Review*, 81 (October 1976), 762–87, seems to have influenced succeeding treatments; and three elaborately researched and highly informative volumes: Frank A. Ninkovich, *The Diplomacy of Ideas: U.S. Foreign Policy and Cultural Relations, 1938–1950* (Cambridge: Cambridge University Press, 1981); Gary O. Larson, *The Reluctant Patron: The United States Government and the Arts, 1943–1965* (Philadelphia: University of Pennsylvania Press, 1983); and Serge Guilbaut, *How New York Stole the Idea of Modern Art: Abstract Expressionism, Freedom, and the Cold War*, trans. A. Goldhammer (Chicago: University of Chicago Press, 1983).

2. Such political sensitivities were not, of course, uniform among any group of modern American painters in the Depression years, including those who would be included in the "Advancing American Art" exhibit; see, for example, the recently published correspondence of Marsden Hartley who, though living in Germany in 1933–1934, seemed unaware of the Nazi attack on modern art. See Marsden Hartley, Charlotte Weidler, et al. "Letters from Germany, 1933–1938," *Archives of American Art Journal*, 25 (1985), 3–28.

## 1. A Strange, Eventful History

1. Peyton Boswell, *Art Digest*, 21 (January 1, 1947), 7, 18–19, 30; John D. Morse, "Americans Abroad," *Magazine of Art*, 40 (January 1947). There were actually two industrial collections: the first, chosen by Davidson for the Cairo exhibit from IBM holdings and emphasizing nineteenth- and twentieth-century American painting (titled "Sixty Americans Since 1800"); and the second, about forty additional pictures chosen from other collections and including works commissioned for company advertising e.g., Georgia O'Keeffe's *Bird of Paradise*, Hawaiian Pineapple Co., Ltd., and Jacob Lawrence's *New Jer-*

sey, Container Corp. of America. The two would be combined for the European tour under the title "American Industry Sponsors Art."

2. Robert M. Coates, "The Art Galleries: The Jury System and Other Problems," *New Yorker* (October 12, 1946), 74–75; Alfred M. Frankfurter, "American Art Abroad: The State Department Collection," *Art News*, 45 (October 1946), 20–31, 78.

3. J. LeRoy Davidson, "Advancing American Art," *The American Foreign Service Journal*, 23 (December 1946), 7–10, 37. A brief digest of some of these points had appeared on the editorial page of the special *Art News* number (cf. n. 2) which was devoted to the exhibit and which would, in Spanish and French translations, accompany it abroad. The page carried a photograph of smiling Assistant Secretary of State William Benton and separate statements under his name and Davidson's describing the rationale and planned chronology of this "modest exhibition . . . selected . . . to show the newest development of American art." Ibid., 19.

4. Davidson, ibid. Frankfurter's classifications are a mixture of standard artistic vocabulary and suggestive phrases clarified by his comments on specific pictures reproduced in the article: "The Old Masters," e.g., Kuhn, Weber, Marin; "Abstractionists," e.g., Davis, Dove; "Realists," e.g., Reginald Marsh, Ben-Zion; "Expressionists, Romantics," e.g., Milton

Avery, Joseph de Martini; "Patterns After Nature," e.g., Julio de Diego, Jack Levine; "The Human Element," e. g., Tschacbasov, Guston; and "Commentators," e.g., Gropper, Gwathmey, Kleinholz. The distribution of pictures for the European and for the smaller South American tours is appended to the Frankfurter article, p. 78. The Whitney exhibit was also reviewed by Frankfurter, "O Pioneers! The Whitney Examines the Pathfinders of Modern Art in America," *Art News*, 45 (April 1946), 34–37, 65.

5. *Congressional Record*, 80th Congress, Vol. 93, Part 4, 5225; the list of galleries from which the purchases were made is appended to Frankfurter, "American Art Abroad," 78.

6. The definitive treatment of the Abstract Expressionist group is by Irving Sandler, *The Triumph of American Painting* (New York: Praeger, 1970). Hilton Kramer discussed some of the political backgrounds against which "Advancing American Art" was organized in "American Art and Its Critics in the Forties: The Big Change," an unpublished lecture delivered at the Montgomery Museum of Fine Arts, January 12, 1984. Neither of the abstract paintings by Baziotes or Gottlieb is illustrated here although Byron Browne's *Still Life in Red, Yellow, and Green* (Plate 2) was also purchased from the Kootz Gallery. The established art magazines themselves did not begin to give any attention to the Abstract Expressionists until well after "Advancing American Art" had been mounted and

recalled (cf. Sandler, p. 212). Robert M. Coates, in a praise-worthy review of a show by the influential teacher and painter Hans Hoffman, refers to Hoffman's being an "uncompromising representative of what some people call the spatter-and-daub school of painting, and I, more politely, have christened abstract Expressionism." "The Art Galleries," *The New Yorker*, 22 (March 30, 1946), 75–76.

7. Robert Hughes, "Aspects of American Painting in the Forties," unpublished essay delivered as a lecture at Auburn University (February 22, 1984), 7.

8. Archibald MacLeish, "Museums and World Peace," *Magazine of Art*, 40 (January 1947), 32–34; Morse, "Americans Abroad," ibid., 21.

9. This occurred in 1938; by 1946 the organizational name had become The Office of International Information and Cultural Affairs. The complex evolution of the concept of cultural exchange and "mutual understanding" between the US and its international ideological opposites into a mode of foreign policy is the subject of Frank A. Ninkovich's *The Diplomacy of Ideas: U.S. Foreign Policy and Cultural Relations, 1938–1950* (New York: Cambridge University Press, 1981).

10. Edwin Alden Jewell, "Eyes to the Left: Modern Painting Dominates in State Department and Pepsi-Cola Selections," *New York Times* (October 6, 1946), 2/8.

11. The first article carried the by-line of Howard Rushmore, who would continue to write *Journal-American* series on alleged Communist subversion themes for several years, "State Department Backs Red Art Show," *New York Journal–American* (October 4, 1946), 6; the two November articles carried the same title, "Debunking State Department's Art," ibid. (November 19, 1946), 17; ibid. (November 26, 1946), 17.

12. The "authority," who allowed himself to be quoted in the November 26 article, was Eugene Speicher. His description as an "outstanding and internationally famous" artist may have been, like the rest of the piece, excessive, but his work, though already dated, was well-known and had been included in the "Sixty Americans Since 1800" exhibit; also he would be appointed as a vice-president in the new Artist's Equity organization (see n. 13 below). The wide and growing public readership of *The New Yorker* would have gotten quite a different view of the subject a few months earlier as its art critic observed that abstract painting was now not only established as a durable art form but "offers values as a means of expression no other method can duplicate." Coates, "The Art Galleries," *The New Yorker*, 22 (April 6, 1946), 83–84. Davidson, by the time he wrote his defense of the exhibit, probably in late November (cf. n. 2), may have tried to address the traditionalist/modernist issue and to mollify such offended artists as

Speicher by emphasizing that "some excellent but conservative painters have been omitted" because of the modernist limitations imposed; "Advancing American Art," 9.

13. The nature of AAPL's predominant membership may in part be identified by describing what it was not. Early in 1947, the group called Artist's Equity was formed, its stated purpose embracing one of the AAPL functions: to expand and protect the artist's economic interests. Although the new organization was not ostensibly established as a rival to AAPL, membership in it was allowed only under carefully reviewed professional criteria: participation in a major exhibit and a one-man show at an established gallery, and representation by a reputable dealer. Kuniyoshi was its first president, and its early membership included not only some "Advancing American Art" figures (Zerbe, Guston, Kleinholz), but representational artists as well (Andrew Wyeth, Thomas Hart Benton). Peyton Boswell, "Artists Equity," *Art Digest*, 21 (April 1, 1940), 7.

14. Albert T. Reid, "League Protests to the Department of State," *Art Digest*, 21 (Nov. 15, 1946), 32; "Diplomatic Art," ibid. (December 1, 1946), 33; "A Letter from the State Department," ibid. (December 15, 1946), 32; "How and Why the League," ibid. (March 15, 1947), 32–33; "More of the Same," ibid., 22 (October 1, 1947), 37. The AAPL, in defense of its presumed territorial domain, had consistently opposed government patronage of the arts, cf. Reid's denunciation of the WPA art projects of the thirties ("this political wet-nurse") when they were closed out during the war. "It seriously impaired the dignity of American art. . . . Rembrandt had no WPA, nor did any of the great artists, including our own." "WPA-RIP," ibid., 18 (March 15, 1944), 28.

15. *Look* (February 18, 1947), 80. Five of the seven pictures are in the present collection: Kuniyoshi's *Circus Girl Resting*, Zerbe's *Clown and Ass*, Shahn's *Hunger*, Gwathmey's *Work Song*, and Tschacbasov's *Mother and Child* (Plates 11, 16, 14, 9, 15); the other two were Guglielmi's *Tenements* and Prestopino's *The Newspaper*.

16. "Best in US Art? They Find It Crazy," *New York Journal–American* (February 18, 1947), 7. Stefan also alluded to the steady stream of protesting letters he had received from all over the country, describing the pictures, according to the article, as "Downright vulgar, corny, vicious, degenerate, un-American, idiotic . . . and Communist-inspired."

17. US Congress, *House Hearings Before the Sub-committee of the Committee on Appropriations on the Department of State Appropriation Bill for 1948*, 80th Congress, 1st Session, 1947, 400–401; ibid., 5188.

18. The exchange over "Advancing American Art" ap-

pears on 412–19 of *House Hearings . . .* , already cited. The first and second pictures held up by Stefan are perhaps Spruce's *Canyon at Night* and de Martini's *The Ravine* (Plate 19); the third, Kleinholz's *Bank Night* (Plate 24); and the fourth, of course, Kuniyoshi's *Circus Girl Resting*; Benton's compliment on this painting was genuine, for he attempted to secure the picture for his personal collection long after the exhibit was dispersed (see commentary for Plate 11). Perhaps the best-known picture reproduced for political purposes after the exhibit became "public property" was Shahn's *Hunger,* published in 1946 by the CIO with the caption "We Want Peace—Register—Vote." Benton's affinity for the language of advertising derived from his earlier experience, before entering public life, as partner (with Chester Bowles) in the firm of Benton and Bowles. His two quoted statements on the political uses of the art program are good microcosmic illustrations of the broad thesis of Ninkovich's book, *The Diplomacy of Ideas* (see n. 9).

19. On Davidson's advisers, cf. Frank Ninkovich, "The Currents of Cultural Diplomacy," 226; the specific attack on Davidson was by Representative Busbey (Republican, Illinois), *Congressional Record,* Vol. 93, 5221; the incident as reviewed by Sidney Hyman, *The Lives of William Benton* (Chicago: University of Chicago Press, 1969), 377–82, is chronologically confused and his somewhat derogatory treatment of Davidson (whose name is not even used—he and his superior, Heindel, are called "the two art lovers"), together with an ardent but questionable attempt to exonerate Benton from any knowledge of the project before the *Look* article in February, is one of the least effective passages in an otherwise informative though laudatory account of Benton's truly notable career; the judgment of the pictures was by Representative Brown (Republican, Ohio), *Congressional Record,* Vol. 93, 5287.

20. The best example appeared in the August 25, 1947 issue of *Newsweek,* "It's Striking, but Is It Art or Extravagance?" The article contains a layout of seven pictures with text and captions originally published and distributed widely by the Republican National Committee under the title "Art for Taxpayers." Five of the seven, including the now seemingly inevitable *Circus Girl Resting, Clown and Ass,* and *Mother and Child,* are identified as the work of artists with Communist connections, and all are described as "prize examples of 'typical American art' according to your State Department." While commenting that President Truman, Secretary Marshall, and Benton had all been embarrassed by the affair, *Newsweek* observed further that "the Administration might regret it even more" (p. 17). Drewes's *A Dark Thought* and Gropper's *Home* (Plates 20a & 21) were also included among the seven-picture layout.

21. Arthur Sears Henning, "Truman Gibes Benton for His 'Art' Exhibition," reprinted in *Appendix to the Congressional Record* for Friday, June 6, 1947, as Extension of Remarks of Edward Mitchell (Republican, Indiana).

22. Quoted by Hyman, *The Lives of William Benton*, 381.

23. Robert Penn Warren, *All the King's Men* (New York: Harcourt, Brace and World, 1946), 461.

24. The latter speech was by Representative Cox (Democrat, Georgia), the two former by Representative Busbey (Republican, Illinois) and Representative Brown (Republican, Ohio), these all being made in the House on May 13–14; *Congressional Record*, Vol. 93, 5220–21, 5287. An extended and illuminating analysis of the thesis that modern art was a convenient symbol of "the forces threatening the psychic equilibrium of the anti-Communist right" is that by Mathews, "Art and Politics in Cold War America," already cited, 762–87.

25. The exchange between Tydings and McCarthy, perhaps foreshadowing their eventual conflict in the Maryland senatorial election of 1950, was over a proposed amendment to the Taft-Hartley legislation, and occurred on May 9; *Congressional Record*, Vol. 93, 4881.

26. All quotations are from the *Congressional Record*, Vol. 93, 5284–90. The first prize at the 1946 Carnegie Institute exhibit went to Karl Knaths for an abstract painting, *Gear*.

Knaths's work also was included in "Advancing American Art" (see Plate 10).

27. The quotations are from Kramer, "American Art and its Critics in the Forties: the Big Change." Although there seems to have been discrimination against abstract artists in the assignment of mural commissions on the Federal Art Project (1935–43), the Project's influence through its employment of thousands of artists—including many of the "Advancing American Art" painters and the major Abstract Impressionists—was quite important in the development of American art (cf. Sandler, *The Triumph of American Painting*, 5–25).

28. "Kennedys Invite Leaders of the Arts to See Inaugural from Honor Seats," *Washington Post* (January 15, 1961), 1.

29. The Dondero quotation is from an interview granted to NY art critic Emily Genauer, and quoted in her "Still Life with Red Herring," *Harper's Magazine*, 199 (May 1949), 88–91; "The Comrade is Decadent," *Time* (August 25, 1947), 68; Peyton Boswell, "Abstract Red Herring," *Art News*, 48 (Summer 1948), 15. Other treatments of Dondero's attacks on modern art may be found in Mathews, and in William Hauptman, "The Suppression of Art in the McCarthy Decade," *Art Forum*, 12 (October 1973), 48–52. Dondero's long connections with such extremely conservative artistic groups as the Allied Artists Professional League (which, as discussed above, led the early attack on "Advancing American Art") was man-

ifest at a ceremony honoring Dondero toward the close of his twenty-five-year congressional career (attended by Vice-President Nixon and chaired by Gen. Ulysses S. Grant, 3rd) when the AAPL President praised him for his "valiant" speeches in alerting Congress and the public "of the Communists' evil designs for pollution of American art." In his own speech at the ceremony, Dondero specifically included "modern" literature with his usual target, stating that both art and literature in their "witless conceit and brazen egotism" show a "contemptible disregard for reality, beauty, and truth." An account of the event appears in the *Congressional Record* (Appendix), 85th Congress, Vol. 103 (February–March 1957), A1172–73.

30. The speech was made on February 9, 1950; see Fred J. Cook, *The Nightmare Decade* (New York: Random House, 1971), 149.

31. See Sandler, *The Triumph of American Painting*, already cited.

32. Clement Greenberg, "New York Painting Only Yesterday," *Art News*, 56 (Summer 1956), 85–86.

33. On the relationship between the avant-garde and its audience, see James S. Ackerman, "The Demise of the Avant-Garde: Notes on the Sociology of Recent American Art," *Comparative Studies in Society and History*, 11 (October 1969), 371–84 (esp. 377–80 in reference to the New York School);

*The Triumph of American Painting*, 269; "Pick Any Card," *Art News* 45 (December 1946), 64; Daniel Catton Rich "Freedom of the Brush," *The Atlantic*, 181 (February 1948), 47–51.

34. The term "paradigm" in this connection is borrowed, perhaps inaccurately, from Thomas S. Kuhn's *The Structure of Scientific Revolutions* (Chicago: University of Chicago Press, 1962), where it is used to describe in an epoch of time those conditions of observable reality and coherent traditions which govern assumptions about the world and the nature of experimental activity—until an anomaly is perceived within that paradigm; for an extended discussion of the applicability of the concept to art as well as science, including the role of the vanguard artist, see E. M. Hafner, "The New Reality in Art and Science," with commentary by Kuhn himself and George Kubler, *Comparative Studies in Society and History*, 11 (October 1969), 385–412.

35. R. W. Gerard, "Science and the Public," *Science*, 106 (July 11, 1947), p. 23; *News and Notes*, ibid. (November 21, 1947), 486.

36. Edmund W. Sinnott, "Ten Million Scientists," *Science*, 111 (February 10, 1950), 125.

37. Quoted in *Congressional Record*, 80th Congress, 93, 5221.

38. Kenneth Clark, "Art and Democracy," *Magazine of Art* (February 1947), 76.

39. Ross Russell, *Bird Lives! The High Life and Hard Times of Charlie Parker* (New York: Charterhouse, 1973), 275. The Dorsey statement originally appeared in *Down Beat* magazine and is quoted by Russell, as are the journalists, 173. Spaeth's statement occurs in *A History of Popular Music in America* (New York: Random House, 1948), 580. Russell's is the principal full-length treatment of Parker's career; see also Brian Priestly, *Charlie Parker* (Tunbridge Wells, England: Spellmount, 1984), which contains a detailed Parker discography and an informative section, 62–68, on his musical technique.

40. Robert B. Heilman, "Melpomene as Wallflower; or, the Reading of Tragedy," *Sewanee Review*, 55 (1947), 154–166.

41. See, respectively, George Biddle, "Modern Art and Muddled Thinking," *The Atlantic Monthly*, 180 (December 1947), 58–61; and Robert Gorham Davis, "The New Criticism and the Democratic Tradition," *The American Scholar*, 19 (Winter 1949–50), 9–19. Biddle's argument here, especially the point concerning art and the "average American," illustrates the wide range of opposition to the growing prominence of non-objective art. Though the point is, of course, central to the diatribes of extreme rightist spokesmen such as Dondero and the AAPL's Reid, Biddle does not carry it to the spurious Communist connection. He was himself a prominent traditionalist painter and New Deal muralist and was an important figure in attempts during the forties and fifties to secure federal support for the arts. The use of the average American's sensibility as an aesthetic criterion would find, inevitably and ironically, a counterpart in the official Soviet stance on art: cf. Kenneth Clark's "Art and Democracy" (published only a few months earlier), which quotes Lenin himself as saying "that a work of art is valuable solely insofar as it is immediately understandable by the average man." Ibid., 74.

42. Truman's comments to reporters occurred during the same week in which the *Look* article appeared and were repeated in Drew Pearson's syndicated column, "The Washington Merry-Go-Round," *Washington Post* (February 18, 1947), 9; Truman's written response to Benton was dated April 2 and was disclosed and widely quoted some two months later, e.g., Arthur Sears Henning, "Truman Gibes Benton for His 'Art' Exhibition—Ridicules Modernism as Depicted by Reds," *Chicago Daily Tribune* (June 4, 1947). The nonpolitical populist dimension of the whole affair is illustrated in the exchange between the President and a group of Ringling Circus girls: "Thank you," they telegraphed, "for your defense of the circus. You know your art and you are not a Hottentot." Replied Truman: "I am delighted to have my judgment verified by experts." Reported from the Sarasota *Herald-Tribune* by Peyton Boswell, "Truman on Art," *Art Digest* (March 15, 1947), 7.

43. The important essay which arranged the tangled chro-

nology of Faulkner's novels and stories and discussed their thematic relationships was by Malcolm Cowley, in his "Introduction" to *The Portable Faulkner* (New York: Viking, 1946).

## 2. Sale and Dispersal

1. Edwin Alden Jewell, "A Crisis," *New York Times* (April 13, 1947), sec. 2, 10; "Artists Protest Halting Art Tour," *New York Times* (May 6, 1947), 24.

2. In Hyman, *The Lives of William Benton* (p. 388), Benton is represented as telling a relieved Secretary Marshall that he would personally "declare that art collection surplus property and throw it on the market."

3. Senator John Sparkman (Democrat, Alabama) to Acting President Ralph B. Draughon, June 2, 1948. This letter and those identified in n. 4 reside in the Auburn University Archives.

4. Frank Applebee to Peyton Boswell, Jr., June 24, 1948; Dorsey Barron, Surplus Property Agent, to P. R. Yurkiewicz, War Assets Administration Customer Service Center, June 25, 1948. Although Auburn's bid and priority status, along with that of the University of Oklahoma, was undoubtedly enhanced by its comprehensive offer of a fair-value price on each painting and its early and scrupulous completion of the complicated procedural details, the institution also made clear in its communications that for the 1947–1948 academic year well over half of its total enrollment and almost two-thirds of the enrollment in its School of Architecture and Fine Arts were war veterans. The only other universities whose bids were approved for purchase were the University of Georgia (which purchased ten pictures), the University of Washington, Rutgers, and Texas A.&M.

5. Drew Pearson, *Washington Merry-go-round*, "Sequel to State Department Art," July 17, 1948; "Retired American Art," *Newsweek* (July 5, 1948), 68. The *Newsweek* article called especial attention to the Auburn haul and featured a reproduction of the exhibit's best-known picture, *Circus Girl Resting*, as well as a painting each by Werner Drewes and Charles Sheeler which were purchased, respectively, by the University of Washington and Rutgers University.

6. See especially Aline B. Louchleim, "The Government and Our Art Abroad," *New York Times* (May 23, 1948), sec. 2, 8; and Lloyd Goodrich, "The Federal Government and Art," *Magazine of Art*, 41 (October 1948), 236–68.

7. Edith Halpert to Hugh Williams, Department of Art, Auburn University, June 29, 1962; in addition to the offer identified in the commentary to Plate 11, Benton's long-time assistant, John Howe, expressed again, two years after the

WAA sale, Senator Benton's "interest . . . in this painting," and proposed that if the University was not "as firmly attached to the 'Circus Girl' as you were a year ago . . . you leaf through the published catalogue of the Britannica collection [of 'Contemporary American Paintings'] and let me know if there are any canvases in it for which you would trade the 'Circus Girl.'" John Howe to Frank Applebee, May 5, 1950, Auburn University Archives.

8. Refregier was represented in the exhibit by *End of the Conference*, purchased in the WAA sale by the University of Oklahoma; the allusion to his restaurant-lounge murals is in *Art News* (August 1946), 11, and an extended account of his difficulties with the Rincon Annex Post Office murals in San Francisco, where he was harassed on the job by pickets from the American Legion and the Sailors' Union, may be found in Hauptman, "The Suppression of Art in the McCarthy Decade," p. 52.

9. Goodrich's comment was made in his article "The Federal Government and Art," p. 238. Davidson's role in the *Sixty Americans* exhibit was mentioned by Peyton Boswell, "Review of the Year," *Art Digest*, 21 (January 1, 1947), 18. Shahn's cover illustration appeared on *Fortune* (August 1948). The *Look* article, "Are These Men the Best Painters in America Today?" was published in the February 1948 issue, 44 ff. Others in the selected group who each painted one of the seventy-nine oils were Franklin Watkins and Jack Levine; those in the group whose water-colors were included in the total collection sold by the WAA were Lyonel Feininger (see Plate 8), who tied with Levine for tenth place, Edward Hopper, Charles Burchfield, and George Grosz. The poll itself may actually have represented the tendency of establishment directors and critics to identify as the characteristic modern American art that form of abstractionist painting which had incorporated a native force and vigor but still reflected ties with French modernism. For a revisionist view of the complex postwar art scene and the thesis that Abstract Expressionism assumed around the turn of the decade a rapid authority and tyranny as *the* typical American art through the conscious efforts of certain vanguard critics, art dealers, and political liberals, see Serge Guilbaut, *How New York Stole the Idea of Modern Art*, trans. A. Goldhammer (Chicago: University of Chicago Press, 1983). A sign of this process, and of interest to this discussion, was the rejection in 1948–1949 by the avant-garde Samuel Kootz Gallery of two "Advancing American Art" painters whom the gallery had previously represented but who were by then no longer regarded as sufficiently modern: the established and highly regarded abstractionists Byron Browne and Romare Bearden (see Plates 2 and 1).

10. Arthur Miller, "Tragedy and the Common Man," *New York Times* (February 17, 1949), sec. 2, 1.

# INDEX

Blacklists, 7
Blue Rider group, 71, 72
Boorstin, Daniel, 4, 8
Boston Museum School, 113
Boston Normal Art School, 141
Boswell, Peyton, 19, 20, 21, 23, 45, 60
Brando, Marlon, 16
Bridge group, 71
Broadmoor Art Academy, 141
Browne, Byron, 70, 85 (commentary); *Still Life in Red, Yellow, and Green*, 70, 84 (plate), 85
Bruce, Lenny, 15
Burchfield, Charles, 153 (n. 9)
Burlin, Paul, 72, 87 (commentary); *News from Home*, 72, 86 (plate), 87, 117
Burroughs, William, 15
Busbey, Fred E., 50, 62, 149 (n. 24)
Byrnes, James, 29

*Caine Mutiny, The*, 16
Cézanne, Paul, 109
Chagall, Marc, 111
Chicago Art Institute School, 89, 101, 107, 111, 143
*Chicago Daily Tribune*, 38
Clark, Sir Kenneth, 50–51, 151 (n. 41)
Coates, Robert M., 145 (n. 2)
Cold War, 3, 4, 57, 65
Communism, 5; fear of, 4, 7, 8; alleged, of artists, writers, scientists, 7; implied, of artists

represented in State Department exhibit, 26, 27, 29
Communist party, 8
Constant, George, 71, 89 (commentary); *Rock Crabs*, 71, 88 (plate); *Seated Figure*, 89 (plate)
Cook, Fred J., 150 (n. 30)
Cooper Union Art School, 133
Cowart, Jack, 107
Cowley, Malcolm, 151–2 (n. 43)
Crawford, Ralston, 91 (commentary); *Plane Production*, 90 (plate)
Cubism, 69, 70, 83, 97, 99, 101, 111

Davidson, J. LeRoy, 19, 36–37, 50, 59, 62, 67, 73, 115; publishes rationale for "Advancing American Art," 21–23; selects paintings for exhibit, 23; stigmatized for failure of exhibit, 36–37
Davis, Joseph, 5
Davis, Stuart, 20, 23, 24, 26, 44, 47, 65
De Diego, Julio, 117 (commentary); *Under Stiff Rearguard Action*, 116 (plate), 117
de Kooning, Willem, 24
De Martini, Joseph, 119 (commentary); *The Ravine*, 118 (plate), 119
Dean, James, 16
*Death of a Salesman*, 66

Dondero, George, 44–45, 149–50 (n. 29)
Dorsey, Tommy, 52
Dove, Arthur, 20, 47, 54, 61, 73, 93 (commentary); *Grey-Greens*, 64, 92 (plate), 93
Dow, Arthur Wesley, 107
Downtown Gallery, 24, 58
Draughon, Ralph Brown, 152 (n. 3)
Drewes, Werner, 117, 121 (commentary); *Gaiety in Times of Distress*, 120 (plate), 121; *A Dark Thought*, 121 (plate)

Eisenhower, Dwight David, 2, 10
Evergood, Philip, 20, 65, 71, 95 (commentary); *Fascist Leader*, 24, 71, 94 (plate), 95
Expressionism, 69, 70–71, 87, 89, 97, 103, 105, 109, 113, 115, 117, 119

Fair Deal, 2
Faulkner, William, 56
Fauvism, 69, 71, 89
FBI, 5, 8, 9
Feininger, Lyonel, 72, 97 (commentary), 121, 153 (n. 9); *Late Afternoon*, 72, 96 (plate), 97
Ferrer School, 123
Fiedler, Leslie, 9
Fine Arts Guild, 113
*Fortune* magazine, 14, 65

## ABOUT THE AUTHORS

**Taylor D. Littleton** is W. Kelly Mosley Professor of Science and Humanities at Auburn University.

**Maltby Sykes** is Emeritus Professor of Art at Auburn University.

**Leon F. Litwack** is a Pulitzer Prize–winning historian at the University of California, Berkeley.